Listening to Stone

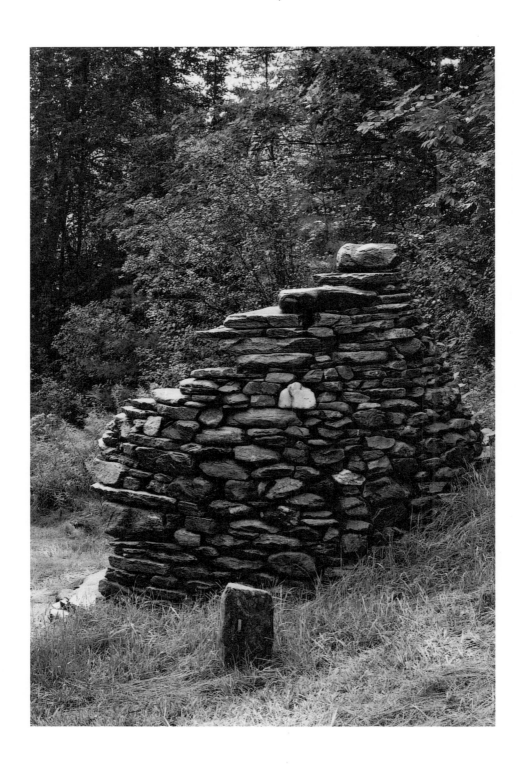

Listening to Stone

DAN SNOW

PHOTOGRAPHS BY

PETER MAUSS

ARTISAN

All dry stone constructions were completed between the years 2000–2007. Richter property projects depicted on pages 18, 21, and 102 were built in collaboration with Win and Archie Clark. The Sheep Shed on pages 64 and 67 was a collaboration with Dan MacArthur, Michael Weitzner, and Deiter Schnieder. All other projects were done by the author working alone.

Published by Artisan
A Division of Workman Publishing, Inc.
225 Varick Street
New York, NY 10014-4381
www.artisanbooks.com

Library of Congress Cataloging-in-Publication Data

Snow, Dan.
 Listening to Stone / by Dan Snow; photographs by Peter Mauss.
 p. cm.
 ISBN 978-1-57965-371-2
 1. Photography of rocks. 2. Dry stone walls—Pictorial works.
 3. Dry stone walls. 4. Mauss, Peter. I. Mauss, Peter. II. Title.
 TR732.S66 2008
 779'.36—dc22

 2008006136

Design by Stephanie Huntwork
Illustrations by James Williamson

Printed in China
First printing, October 2008

10 9 8 7 6 5 4 3 2 1

FOR ELIN

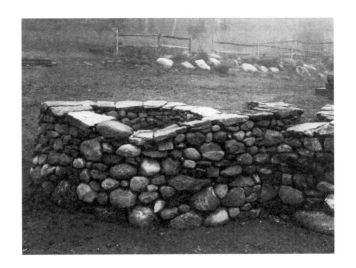

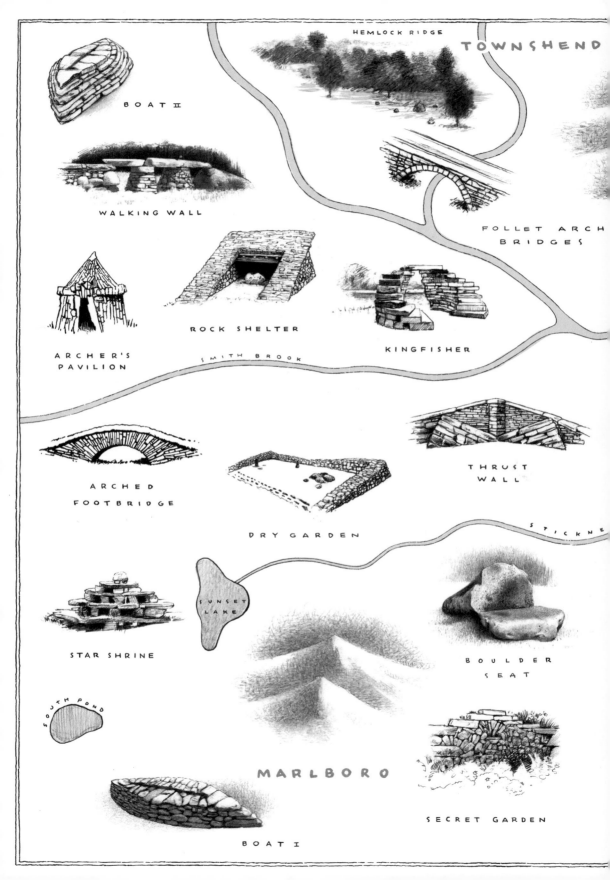

BOAT II

HEMLOCK RIDGE

TOWNSHEND

WALKING WALL

FOLLET ARCH
BRIDGES

ARCHER'S
PAVILION

ROCK SHELTER

KINGFISHER

SMITH BROOK

ARCHED
FOOTBRIDGE

DRY GARDEN

THRUST
WALL

STICKNE

STAR SHRINE

SUNSET
LAKE

BOULDER
SEAT

SOUTH POND

MARLBORO

SECRET GARDEN

BOAT I

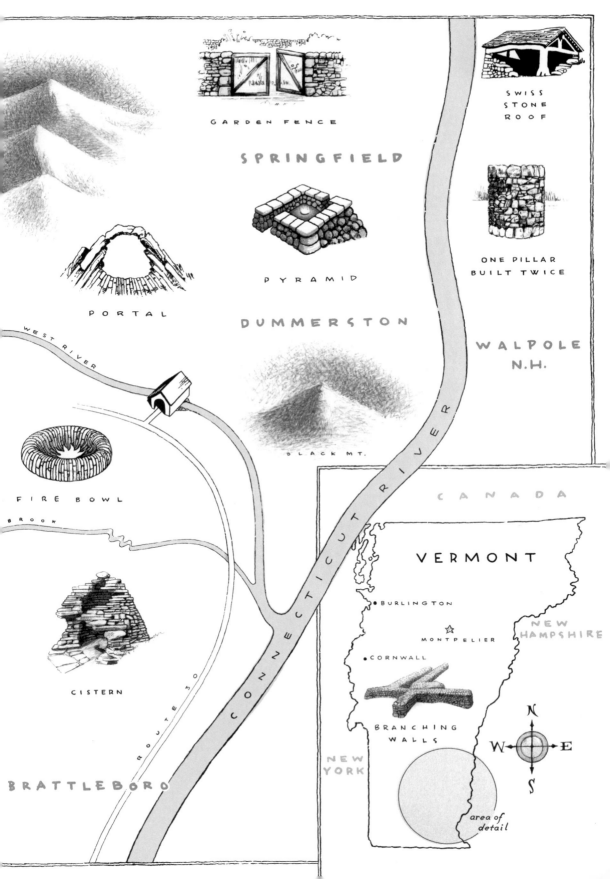

GARDEN FENCE

SWISS
STONE
ROOF

SPRINGFIELD

PORTAL

PYRAMID

ONE PILLAR
BUILT TWICE

DUMMERSTON

WALPOLE
N.H.

WEST RIVER

CONNECTICUT RIVER

FIRE BOWL

BLACK MT.

BROOK

CANADA

VERMONT

CISTERN

BURLINGTON

MONTPELIER

NEW
HAMPSHIRE

ROUTE 30

CORNWALL

BRANCHING
WALLS

NEW
YORK

BRATTLEBORO

N

W E

S

area of
detail

CONTENTS

PREFACE

"I work with stone because stone is so much work. Physical labor stimulates thinking. The more engaged I am in working the freer my thoughts become. It takes a lot of stone to stay working. I appreciate stone for its abundance and for its willingness to play along." —Dan Snow

THIS BOOK BEGAN WITH THE IDEA OF GIVING THE READER a close-up look at some of my recent works in dry stone: the techniques I employed, the stones I handled, and the landscapes I encountered in the course of their making. It seemed like a straightforward enough endeavor, but as I got into the writing it became evident that what I had to offer on the subject was being matched at every turn by what the subject had to offer me. In contemplating the works in stone, memories bubbled up and new understandings configured themselves. I recorded them as they appeared along the way, and since they were a gift to me, I felt glad I could pass them along. I learned that the voice of stone speaks softly but not in confidence. Listening to stone is an experience to be shared.

Eventually I did manage to cover the original subject. Some of the constructions were designed to perform a utilitarian function while others are simply bits of whimsy. All were built based on principles of dry stone construction that have proved themselves over the millennia. In my travels I have witnessed the universality of those basic building principles and seen how the long-lived stone work from disparate cultures share similar characteristics.

Being a terrestrian at heart, even when I'm not handling dry stone, it's the earth that intrigues me most. The natural landforms of New England are endlessly fascinating to me, both for their geologic and human histories. I don't have to go far from home to be swept up in the physical dramas and cultural dynamics that have moved within and across my native landscape.

Walling is a solitary activity for me. So I was delighted to find, while writing about the different works, how much I associate each one with specific human relationships in my life. Family members, friends, customers, and fellow travelers in the work-a-day world played an important role in the conception of the stone works, even if they weren't physically present during their creation. While this book is meant to highlight a select group of my projects and describe the process of their creation, the locales they're grounded in, and the experiences that inspired them, it is also meant to introduce the reader to the personalities behind those works. With their love and care, I've never labored alone.

—Dan Snow, Dummerston, Vermont

STONE CALLING

"Knowledge is only obtainable by friction and motion."
—JAY PARINI, *One Matchless Time*

THE VOICE OF STONE IS AN ECHO FROM THE DEPTHS of time. The language is lost to our ears but something of its essence can be translated through touch. Stone speaks through the hands when a dry stone construction is created, because touch, being the oldest of our senses, is most sensitive to its language. Seeing is really just a way to touch beyond our arm's reach. Having an eye for stone, as it's said dry stone wallers do, is to have sight that has been schooled by the fingertips. With every stone lifted from the ground you will hear stone calling.

A dry stone wall's source of life is found in the spaces between the stones. The time between placing one stone and the next on a wall is the space in which a wall is conceived. To be efficient in the task of walling, each stone is handled as briefly as possible. But that's not to say those moments are insignificant. The thinking that goes along with the placement of each stone incrementally adds to what is, ultimately, the wall conceptualized. The stones provoke the thoughts and the thoughts give birth to the form. A finished construction is a thought process petrified. Within a wall are all the moments that created it. They remain there like hidden messages slipped between the stones as they were placed. The finished wall's character is defined by the spaces between the stones as much as it is by the stones themselves.

An act of cocreation manifests itself in a stone wall. Nature makes the shapes and the wall builder puts them into relationships. Assembling stones

in a landscape, the builder strives to be in harmony with the materials and the prevailing conditions. A dry stone wall is both a human work framed by nature, and a work of nature touched by humanity.

Some of the earliest challenges to human ingenuity were met with innovative arrangements of stone. The skills and techniques of dry stone construction likely developed out of a need for shelter. Ledge overhangs became safe domestic spaces when augmented and enhanced with dry stone walls. Over time, with further refinement, the craft was employed to create stout fortifications, sophisticated observatories, and beautiful temples. The sixty massive stones that comprise the inner ring of Stonehenge and the thirteen thousand marble blocks of the Parthenon were all laid dry, without mortar. Dry jointed stone held its place in the sun for a very long time, until new technologies pushed it into the historical shadows. The work of dry stone wallers slipped into obscurity but never completely disappeared. Although it may seem an anachronism in this day and age, dry stone construction is still widely practiced. Our long association with dry stone is not near its end. We're simply in a time of transition. As Lao-tzu wrote, "Being great, it passes on; passing on, it becomes remote; having become remote, it returns."

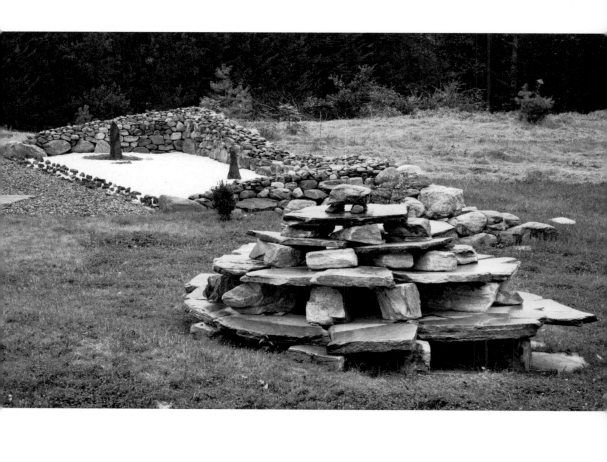

"Work is the key to creative growth of mind."
—ELIEL SAARINEN

*"When someone expends the least amount of motion
on a given action, that's grace."*
—ANTON CHEKHOV, *The Seagull*

TUSSLING

THE RELATIONSHIP I HAVE WITH THE LANDSCAPE OF
Windham County, Vermont, is not that complicated. If I had to sum it up in a
word, I'd call it a tussle. From an early age, while growing up here, the earth
of this small world has beckoned me to romp across its contours. Whether
pushing my balloon-tired bike up Strand Avenue in Brattleboro, Vermont,
for the ride back down or lugging a canvas bag full of the *Brattleboro Reformer*
to customers on my after-school paper route, I spent a lot of time as a kid
negotiating the three-dimensionality of my home turf, for both fun and
profit. Winter nights found me with a pair of heavy wooden skis slung over
my shoulder, trudging up snow-packed steps, on my way to the top of the
ski jump at Living Memorial Park. The climb and the cold were worth it
for the bracing slide down the grooved tracks of the trestle, exciting liftoff,
thrilling flight, and teeth-chattering rush to the end of the outrun. That,
of course, was on the rare occasion I didn't crash while landing and wind
up splayed out on my back, skittering to a ragged halt in the slough of the
transition. But even after getting smeared across the landing hill I would
invariably pick myself up and march back to the top for more. I just wanted
to be out there, taking in whatever the landscape had to dish out.

The tussle has followed me into adulthood. Workdays find me grappling
with stone; hoisting it up and onto my bent knees, hugging it to my gut,
and shoving it into position with the heels of my hands. I'm often wedged

into the landscape on the edge of my boot soles, clamoring for purchase on a slide of loose gravel or slick of wet clay. With earth underfoot and stone all around I'm tied in a love knot with the land. To the outside observer it may look more like a fight than a dance, with all the pushing and shoving that goes on. Fortunately for me, it's not a contest of strength or endurance. My mortal coil would make a short-winded opponent pitted against earth's immeasurable staying power. It's more of a play for the moment. The planet parries my jabs with the heft of its weight spinning through space. I bob and weave, trying to slip through gravity's net. If my wrestling some stone toward a fresh aspect gets this old Earth to crack a smile then we both have had our moment.

A swim across the whisper-quiet waters of Marlboro's South Pond is invigorating. I'm exhilarated by a breathless scramble up the ledges of Dummerston's Black Mountain. But to feel fully a part of the earth's workings I have to get myself in gear with it. I need to be one of its agents in the process of building up and breaking down. When I do manage to fall into step with the earth's ongoing parade, then I think I can declare, with considerable pride and no less a degree of tomfoolery, "I'm not here for long, but I'm here for good." And that's about as close as a member of humankind gets to having a welcome hand in the affairs of nature.

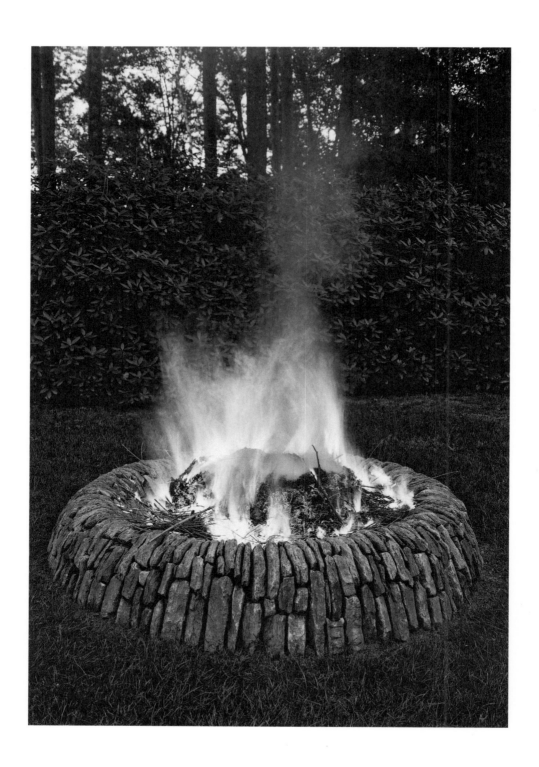

FIRE BOWL

ONE SUMMER DAY I FOUND WILL ACKERMAN contemplating a hole he'd dug in his yard. The hole, he said, was for the foundation of a fire pit he was thinking of building, and it was his intention to fill the five-foot-by-five-foot hole with cement because, in his mind, that was how one began such an enterprise. Besides being a guitarist, songwriter, and music producer, Will is also a skilled woodworker. He's built everything from rough hemlock timber frames to butter-smooth cherrywood bookshelves for his home and studio, but masonry, he'd freely admit, is not his strong suit. When I asked him what was going to happen next he was stumped for an answer. And when I said I thought fire pits were round, he threw up his hands, and replied in mock frustration, "If you're so smart, why don't you make it!"

I wasn't looking for a job. I was just trying to have some fun at Will's expense. That's what friends are for. But the hole was mine now, and Will was having the last laugh. He knew what he ultimately wanted, a place to watch a fire flicker at night. How he was going to get that, he'd decided to leave to me. I looked into the square hole and saw a round bowl.

In my first year of industrial design school I was taught how to make a three-dimensional model by spinning wet plaster of Paris against a stationary template. An accurate model of a symmetrical form, such as a cup or saucer, could be quickly created by heaping whipped-cream consistency plaster onto a turntable and spinning it against a thin sheet of ridged plastic cut in the profile of the intended form. The resulting object, when dry, could be held and examined to assess its design qualities. Thirty years later, memories of my model-making days at Pratt Institute came back to me.

To build the shape of a bowl in dry stone I would need a template, some-thing simple but sturdy. This bowl could not be spun, as the ones were in design class. The template would have to do the spinning. Taking a straight six-foot piece of 3/8-inch steel rod, I bent two-thirds its length into a curve mirroring the shape of the bowl from its center point to a point along the outside edge where it would meet the ground. (To visualize the shape of the bent rod, take a pencil and paper, draw a horizontal line, attach a question mark at the end, and then turn the paper 90 degrees counterclockwise.) The straight section pointing down became the spindle for the curved section to spin from, like a weathervane. To hold the template upright, the bottom twelve inch of the spindle was buried at the center of the hole. Stones were edge-set in stone dust, starting at the center of the bowl and radiating out, with their top surfaces just touching the bottom edge of the template. The stone along the rim of the bowl was the last to be set. With all the pieces in place the template was pulled. The bowl was ready for fire.

On occasion I stop by Will's place, and find him outside under the stars poking a stick at live embers in the fire bowl. We stand around the edge, stare into the glow, and catch up on neighborhood news. We're both sat-isfied with the way things turned out. He's glad he didn't wind up with a square fire pit, and I'm glad I didn't grow up to be the industrial designer I thought in school I'd become. The night sky illuminates the features of the river valley. Black Mountain's dark silhouette appears in dusky relief. Curiously enough, its shape looks a lot like an upturned mixing bowl.

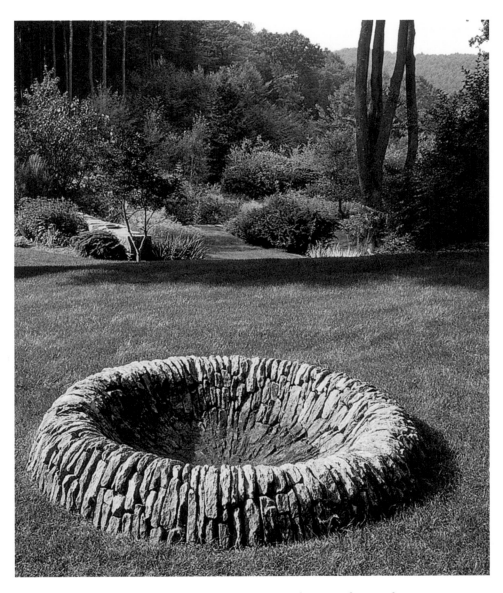

While being used, an object's appearance is secondary to its functionality. When not in use, the way it looks is all we see. Form may follow function but the eye follows form.

DRY GARDEN

MY CONFIDENCE TO ATTEMPT AN INTER-
pretation of an Asian garden tradition, in the
backyard of a Vermont home, came out of a chance
encounter with a shy Japanese student in a far corner of northern Europe.
Six students from the University of Art and Design's Environmental Art
department were constructing a dry stone sculpture in the countryside
north of Helsinki. I was their instructor. Taheshi Hamana had recently
arrived in Finland for a semester abroad from his university in Tokyo. He
spoke some English but, like me, spoke no Finnish. The other students
spoke English, but when among themselves they most often conversed
in Finnish. It was difficult for the young man to fit in with his peers. The
school, the city, the entire culture was new to him. Even the time change
was a challenge. Jet lag hung on him like a shroud. He shuffled around
the building site like a somnambulist. While the weeklong workshop was
going on I had the impression that Taheshi wasn't much interested in the
task at hand. He was quiet and kept to himself. But when the wall was
completed, and the students were back at the university preparing a pre-
sentation about the workshop for a symposium, he suddenly came alive.

Throughout the week he'd been unobtrusively documenting the work-

shop's progress through photographs and video. In the studio, working with his materials, and in the gallery mounting a display, Taheshi was suddenly energized and animated. He *had* been engaged in the process of building the wall, but not in a way that any of the rest of us understood or appreciated until the end of the construction.

As the symposium came to a close, Taheshi presented me with a CD of digital images. We sat down together and took a look at them on his laptop. They were photos he'd taken in Kyoto, the old capital of Japan, which has many revered gardens and shrines. They'd clearly left a strong impression on him. As he clicked through the images, Taheshi appeared to be reliving his experiences in Kyoto. Hearing his descriptions of the sacred stones and seeing the honored spaces through his eyes, I felt as though I'd traveled there with him.

Two years later, when Thom Dahlin and Gregg Van Iderstine asked if I could build a Japanese-style garden for them, I said yes without hesitation, even though I'd never actually experienced one firsthand. I like to think the dry garden on Smith Brook contains a touch of the spirit found in Kyoto's venerable gardens, and for that I have Taheshi to thank.

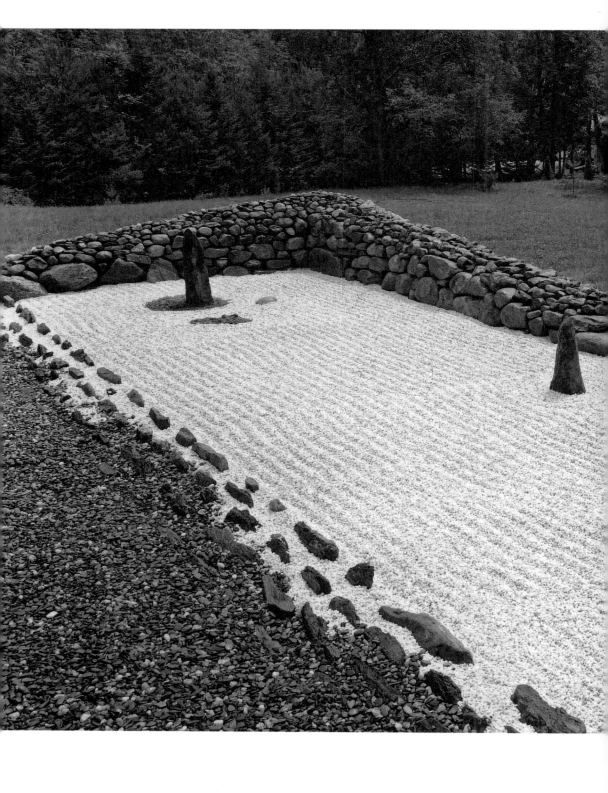

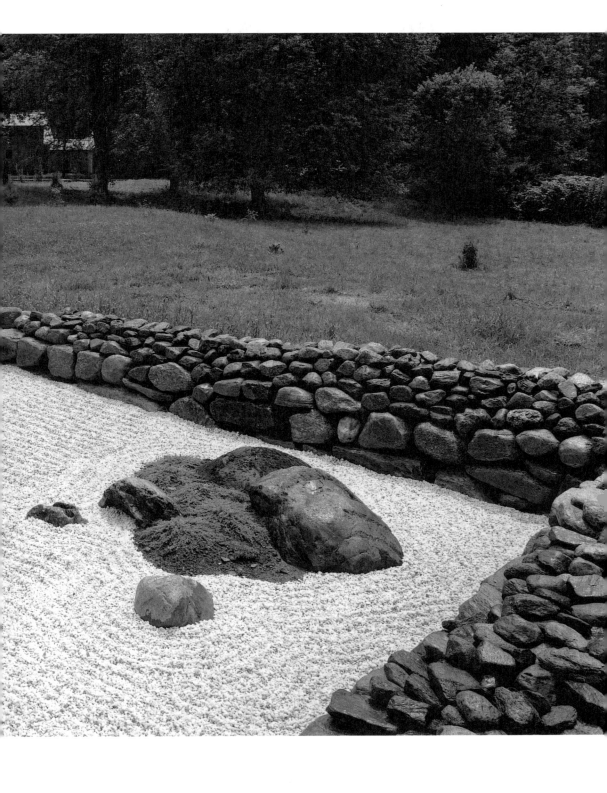

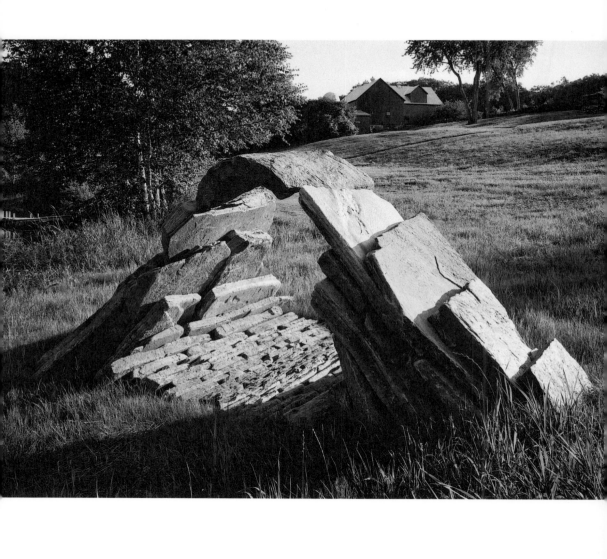

PORTAL

STUART BROWN STARTED OUT HIS WORK life as an apprentice pattern maker, learning how to translate a mechanical drawing into a three-dimensional model. He moved on from there to cabinetmaking and then to general contracting. As a kid during the Depression Stuart played in the streets of Brattleboro with my father, but I first met him when we were both working at a site on Black Mountain Road. It was his job to tear down the kitchen portion of an old farmhouse and replace it with an elaborate two-story addition. The drawings for the construction, and extensive landscaping, came out of a down-country architectural office; plans, Stuart said, we had to make right without making the architect's look wrong. He may not have dressed like a diplomat, in his safari hat, his pants hitched up with suspenders, and a camera slung around his neck, but he managed job site affairs like one. In conversation he would always want to know and understand the other guy's viewpoint before formulating his own opinion. He tried to see that everyone came out a winner in the end.

From Stuart I learned that working was only half the job—you had to get along with people too. For him that was the fun half. My work was to bring the grades up around the new building with retaining walls, punctuate the walls with staircases, and cap them with pathways and patios. It was a big task for a young waller, one made less stressful by the congenial presence of Stuart Brown. He encouraged my progress and expressed his confidence in my abilities, though always in a roundabout fashion. He wouldn't let me believe I couldn't do better.

I continued to build features on Joanie and Nicholas Thorndike's property over the years. Stuart retired but didn't lose his interest in what his neighbors were up to. I liked getting his surprise visits, unofficial inspections they might more accurately be called. If he'd come by when I was fabricating the Portal I'm sure my intentions in the enterprise would have been intensely questioned.

I had dug a three-foot-deep hole in the hardpan earth where it was to be sited. The hole quickly filled with groundwater. A loader bucket's worth of 1½-inch crushed stone was dumped in, disappearing to the bottom. Not an auspicious beginning, but I had a fire in my belly for making the piece, and no amount of floodwater was going to put it out.

The soggy footings finished, I banged together a wood frame to support a pattern that hung in the exact position the top stone would ultimately assume. (Being an old pattern maker, Stuart would have especially enjoyed seeing this part.) After that it was a matter of setting the floor stones that led to the sidewall stones that reached up to touch the pattern. With that all arranged, the pattern was removed and the wood frame dismantled. The top stone, a true geologic tour de force, was lowered into place to finish the piece.

Work completed, the up-thrusting energy of the earth-bound stone met the spring coil tension of the curved lintel. The ovoid space in the middle was charged with a kind of kinetic energy. An invisible vibration pulsed from it. Whatever else it was or wasn't, I was sure I'd just created a local attraction for all spirits of a playful nature.

Maybe Stuart did come by when I was building Portal. I was to learn later that the morning of the day I completed it, he had passed away peacefully at home, a couple of miles down Black Mountain Road.

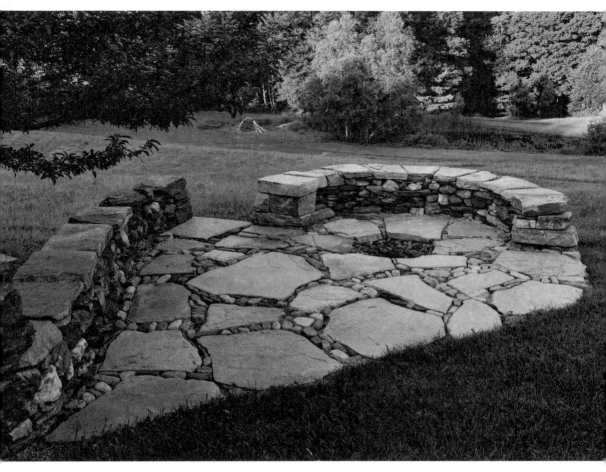

Portal can be viewed from this fireplace terrace. The character of one dry stone sturcture is deepened by its proximity to another. Something magnificent becomes sublime when entered into a relationship (art is born from a sense of belonging).

LOCAL ASPECTS

LONG AGO, LOOKING OUT FROM THE HEIGHT OF MY LAND, I would have gazed upon a broad, beautifully iridescent blue lake. For four thousand brief geologic years, lake waters submerged this valley and others around central New England. But times and landscapes change, so these days I must content myself with a glimpse here and there through the trees of the West River flowing at an elevation far below that of the long-lost lake surface. Still, in its time and place, the West is unique. It's fully a Green Mountain State creation—the first major tributary of the Connecticut River to make both its headwater and outfall within Vermont's borders.

All the contemporary currents of Windham County share an ancestry with the torrents and flumes of Vermont's glacial past. Below their flows are some of the very same stones. Many were plucked up in the icy hold of an advancing, mile-thick glacier, and then left behind in the glacier's retreat to roll and tumble in its rushing melt waters. The West River valley is wide compared to the narrow ravine that Stickney Brook passes through on its journey east from Sunset Lake. But even the most generous expanses of bottomland along the banks of the West River are mere scraps compared to the alluvial plains of the Connecticut. The dry lowland soils of Dummerston are full of stones because they were once the streambeds of an ancient river system. I find these rounded cobbles and boulders, available at local gravel pits, very useful additions to my arsenal of building supplies.

Five miles before its discharge, the West passes between the village of

West Dummerston and Black Mountain, the township's crown jewel. The dark pine forest of the mountain's upper reaches is the biological result of its unique geologic standing. The smooth "pluton" of white granite supports some evergreen growth but not very much else. When early, non-native visitors to the region spied it from a distance it stood out from its deciduous-forest-clad neighbors. It looked "black." The mountain's surface is cracked and crazed and mammoth chunks of loose rock, a hundred tons apiece, drape across its slopes. The hardness of the great dome would seem ineffaceable by any actions short of glacial, but human interventions have left their mark. A quarry, operated during the first third of the twentieth century, extracted stone from a pit cut into the base of the mountain's western flank. Up close, the cavity is huge. The fifty-man operation cut stone for many monumental constructions including the dam across the Connecticut River at Holyoke, Massachusetts. But viewed from my home on the hillside above West Dummerston village the abandoned excavation looks like no more than a small bite taken from a big candy apple. Granite is no longer quarried in town but remnants of the industry's glory days remain. Cut slabs and blocks from Black Mountain continue to be reused and recycled.

Tumbled, shifted, dropped, rolled, lifted, arranged, or reassembled, stone makes its way to new aspects by any willing agent. I see myself as just one more way stone has found to be itself.

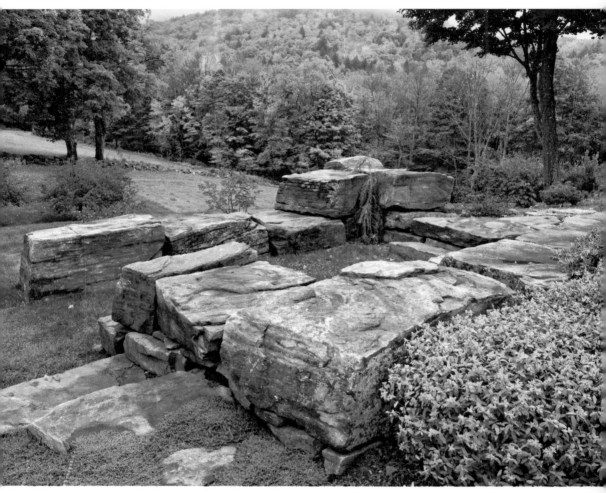

Frost and time have worked together to split massive blocks of stone from the earth's mantle. Nature is the most artful delver.

DELVING

A COUPLE OF SUMMERS AGO MATT BETTS INVITED ME OVER to his place to look at his collection of old granite curbstones. The stones had been cleaved many years before from exposed ledge on Black Mountain with a few simple hand tools and an eye for the grain of the stone. Granite is dense, the heaviest of stones. But something about these particular stones gave them a look of lightness and delicacy. Measuring as long as a man is tall and as wide as the width of his shoulders, they were barely as thick as a fisted hand. The method of their extraction was clean, and remained clear. Hand-drilled holes (half inch in diameter, three inches deep, and eight inches apart) had iron wedges hammered into them until the pressure opened fissures next to the holes that ran out and connected with one another to form one long straight crack in the quarry wall. The slab separated from the bedrock and lay on the quarry floor, its surface a mirror image of the newly exposed wall face. The knobby texture of the freshly cut stone must have invited the stroke of the delver's dusty palm. I was tempted, myself, to brush a hand lightly across the surrendered planes, now mottled with age.

Delving is the act of splitting stone, but it is also the ability to look into a stone, to see with the mind's eye the way the grain runs through it. A delver can sense the tension held by a stone and know how a seam will open before it does. The measure of a stone is taken from the sonic depths of the delver's being, at that moment when the still point between breaths and still point between heartbeats converge.

Matt had hauled the discarded curbstones in the back of his pickup from the site of the newly constructed roundabout at the intersection of routes 5

and 9. It was his intention to install them as sill stones under his cabin, but he didn't get to it and now it's too late. Matt made it clear that he was only letting the stones go because he had to move. The land he had always lived on was not his exclusively. Aunts and uncles shared in its ownership and wanted to sell. Matt would have liked to stay but couldn't afford to buy out the rest of the family.

When I first arrived at the farm I found Matt at the end of his rope, literally. He was trying to start the one-cylinder engine that powered the hay baler. His nerves were as frayed as the old rope wound round the Taurus-shaped iron pulley that protruded from the side of the heavy engine. Pulling with all his might, the rope unspooled but didn't transfer enough momentum to the flywheel to get the engine to "pop" and run. Again and again he tried but to no avail. Overhead, a steady wind sent a flotilla of tall white clouds sailing from horizon to horizon dragging their own shadows, like phantom anchors, across the fields. The clouds were massing toward rain, and the machinery was misbehaving; everything seemed to be conspiring against getting the hay in.

Matt had recently contracted a bad case of poison ivy. Itchy patches blistered up on his arms and abdomen. Early in the day he'd taken his shirt off to avoid the chafing it caused. The consequence of which, by late afternoon, was sunburn. Life is sometimes an assemblage of good intentions cascading to bad effect. The bare skin of Matt's shoulders and forearms was burned bright pink. He complained out loud about it to no one in particular and carried on with trying to start the engine. The poison ivy and sunburn were aggravating, but I could tell that what was really paining him was the loss of his home.

When it was time to talk price for the stone, Matt threw out a figure that was half as high as I knew I'd be willing to go, though I didn't say as much. I did say I thought it was a fair price. He admitted, quicker than he had any need to, that it was twice what the stone cost him. We had a deal.

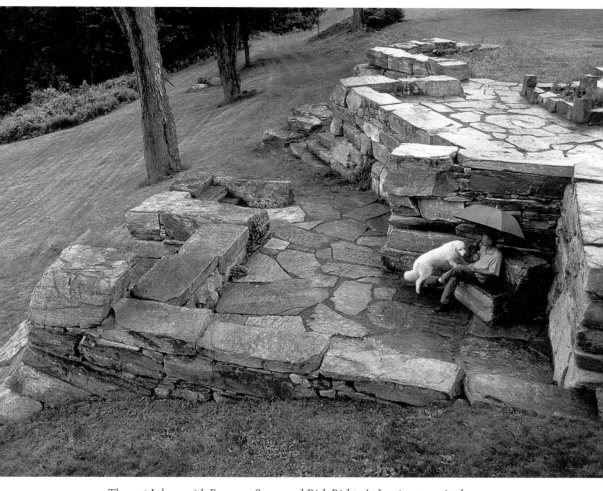

The seat I share with Benozzo, Susan and Rick Richter's dog, is a stone in the shape of a chair. Its placement on the terrace turned an open space into an outdoor room.

CHAIN

stone work. It's long enough to loop around a good-size slab or boulder and hitch up to the bucket of a backhoe, or loader, for lifting. With "grab" hooks attached to both ends a chain becomes a versatile tool.

When a chain is in tension it's a picture of stress and strain. The force of the pull is distributed equally to all the links and to the points where they cradle one another. Every link feels compression and expansion. They are both hugged and stretched at the same time. At its ease, nothing is more relaxed than a chain. Falling to the ground, the links tumble and spill onto one another in a heap, like elephant seals slumbering on a beach after weeks of migration on the open sea, individuals at rest but still connected by their collective destiny.

While a chain is in use it polishes itself. The constant dragging and scrapping, bumping and jostling, brush the steel clean. The burnished surfaces are smooth and on a summer day warm to the touch. Gathering a chain up is like handling a living thing. It molds itself to the shape of the hands. Slung over a shoulder a length of chain drapes on the chest, and down the back, to bounce and "clink" against a boot heel while walking.

Activity shines a chain but opens it up to tarnish. Left coiled up behind the seat of the parked loader, exposed to any rain showers that might pass or dew that falls in the night, a chain will quickly develop rust spots. If it sits for long, the spots grow until the chain turns a sickly orange color, and then a prickly reddish brown patina begins to grow. Picking up the chain with bare hands is no longer inviting. A gang of us were eating lunch on a construction site one day. We were talking about personal injuries and the question

came up, "If you pull a muscle is it better to keep working or take a day off?" Opinions ranged the spectrum, but one of the guys had the last word when he exclaimed, "REST IS RUST!" It's better to wear out than to rust out.

Questions arise when lifting a stone with a chain. How does the chain get under the stone to begin with, and how does it come back out after the stone is set on the wall? The business of chaining a stone requires the coordination of pragmatics, mechanics, and intuition. Under the right conditions using a chain is an elegant solution to the problem of moving a heavy, amorphous shape.

The chain itself has no ability to lift. It is only a connective medium between the lifting mechanism and the stone. Chain is malleable and can be shaped to fit the circumstances. A length can be snaked around obstacles and pulled through crevices. When the hook is set and pressure applied the chain snaps to attention, making itself as long as the links allow.

Getting the chain around any given stone is the trick. There's always a lot of air space around and under the pieces in a pile but not always enough room to slide a hand around. A three-foot-long steel rod with a U-shaped bend at the end can be poked through small openings, catch the chain, and draw it back to within grasp. There's a lot of stretching and reaching required to girdle a large stone. It's not always a pretty sight, with all the groveling in the dirt that goes on. But the contortions are worth it if the chain is set so that when the stone is lifted it rises out of the pile, teeters in its chain sling for a moment, and then settles to the exact orientation needed for it to set easily on the construction.

Chain is often trapped by the weight of the stone once it's in place.

When large cover stones are absent in a supply, a wall can be topped with a heap of cobbles.

Getting the chain out requires prying one edge of the stone up enough to put a temporary shim under it. With a scrap stone under the edge, enough space is created to free the chain. The wedge of rock that blocked up the stone is removed by prying once more on the side of the stone. With the shim removed, the stone settles down into its final resting place.

A chain is a very useful tool, but even more than that, it's enjoyable equipment to handle. Slinging a chain around adds musical moments to

the day. The links ring against one another, making a cheerful sound, like sleigh bells. When pulled through a narrow opening, a length of chain beats out a staccato percussion against the stones, a most satisfying "thrumming" sound. When dropped in a heap it makes a sound like a sack of doubloons hitting a tabletop in a pirate adventure. Hearing a chain cascade on itself offers many pleasures of association. In the course of a working day, we take our amusements where we find them.

When I began clearing trees to build my home I unearthed an old logging chain. A neighbor, Cleon Barrows, told me that my property had been clear-cut in 1913. He remembered because it was his first year in the little red schoolhouse at the bottom of the hill. All through that winter he looked out the window from his classroom bench and watched as loads of logs came off the hill on horse-drawn sleds. The chain I found buried under a thick mat of leaves had hand-forged links and broad, flat hooks at both ends. When I yanked the chain up out of the mat of forest debris the iron was pitted, corroded with rust, all dark and moist like the earth. When I had pulled half of it up through the litter it stopped coming. It felt stuck under something, so I tore into the ground with my hands until I discovered what was gripping it from below. The root of a black birch tree had grown through one of the links. It expanded its girth over the years until it encased the link in live wood, trapping the chain, earth fast.

It's easy to lose a chain on the forest floor during a logging operation and not be able to find it again. The logger who left that chain behind may not have known it was missing or had searched for it, but in vain. There it lay until I stumbled on it one day and hacked it free of the root's grip with an ax. Compared to today's chains it seems ungainly. There's too much material in its eight-foot length. The links don't nestle neatly together when dropped in a heap. I've never had occasion to put it to use. No doubt there's goodness left in it still, but the modern high-tensile chain is stronger, lighter, and much easier to handle. The old chain now decorates a post in my barn, covered in dust and spiderwebs. There it hangs, the one and only artifact I've found on my property in evidence of human activity here before I arrived.

In the life of Matt's curbstones (described in "Delving"), the pieces had gone from the West Dummerston quarry, to the curbside of Putney Road at the north end of Brattleboro, to his farm in East Dummerston. From there they traveled back to West Dummerston to be turned into doorsteps for my neighbor's home and a bench beside the fire pit in my own front yard (right). The wandering granite slabs took a little more than one hundred years to complete their fifteen-mile circumnavigation of town.

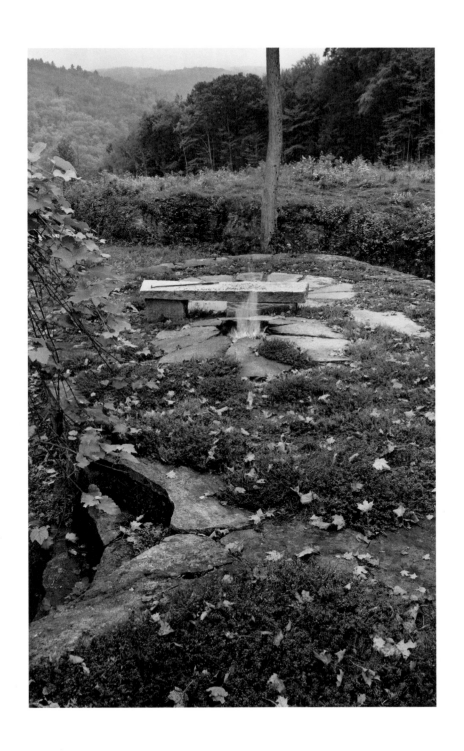

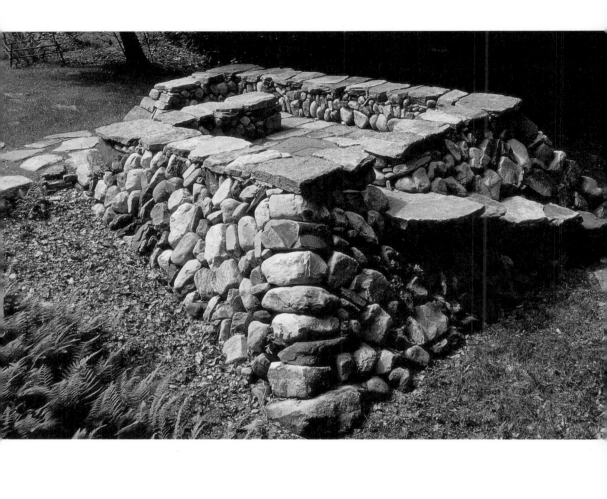

PYRAMID

 THE VISION FOR THE PYRAMID WAS OF an outdoor living room illuminated by candle and campfire light. The terrace atop the Pyramid would be accessed from a grade-level entry at the height of the slope, and a stairway entry from below. The short wall that surrounded the terrace would provide seating for evening get-togethers and a resting place along the fern-edged path that looped through the yard of Richard Epstein's cozy log cabin, and around the pond favored by muskrats and wood ducks.

Before the building began, Richard and I stood at the center of the site and looked above, twenty feet in the air, at the place where we needed to fix a point. From it we could find where the four corners of the Pyramid would meet the earth contours. The sober employment of mathematics could have done the job from the safety of ground level, but we preferred to take to the air. With extension ladders propped against swaying tree trunks, we climbed up and strung rope. From the center of the span a small, pyramidal shape, made from wood, was hung. Four strings pulled from the apex of the shape followed its edges and continued down to the ground to establish the full length and final position of the Pyramid's corner lines. To make a more sturdy construction guide, steel rods were pounded into the ground to replace the strings. From the corner rods, string lines were pulled to guide the building of the slanting wall faces.

Every job comes with its own set of uncertainties. Completing the job means clarifying those uncertainties and nullifying them one by one. One of the biggest uncertainties can be eliminated at the start if the ultimate shape the work is to take can be established right away. Our risk of life and

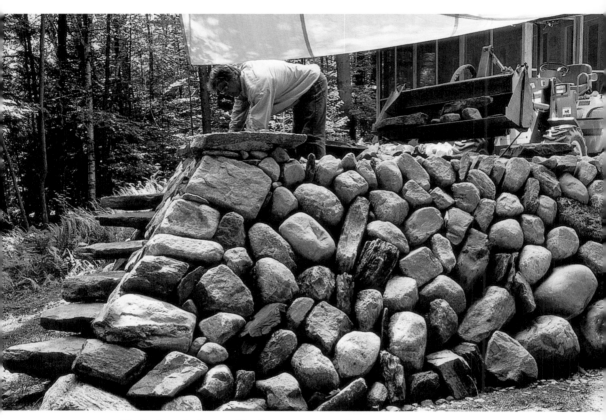

The bucket of a front-end loader acts as a store shelf to choose stone from. A tarp overhead provides protection from sun and rain. Small comforts to ease the day's labor.

limb in the treetops securing guide lines paid off later in the building of the Pyramid. Guide lines ease the burden of uncertainty by defining the shape of what's to be built.

My choice of smooth, oblong stones rather than sharp-edged, rectilinear chunks for building the flat planes and crisp lines of the pyramid was predicated on the notion that their use in the construction would soften the hard geometry of the shape and blend it into its woodland surroundings. Unlike most projects where the stones are laid with their bed planes on the horizontal, in the Pyramid stones were laid on their vertical axis. They were perched on edge, the work rising in sawtoothed courses. The batter of the wall face was so extreme every stone had to be packed behind, immediately as it was placed, to keep it from toppling backward. The solid core of the Pyramid became the crutch the face stones leaned against on their march up the wall. After flat stones were laid across the platform's enclosing walls, a fire pit was sunk in its center. With a flame shooting out of its top the Pyramid looks like a cross between a Mayan temple and a volcano.

Comparing a small construction in my hometown to the achievement of an entire civilization and the fiery formation of a mountain is hubris, I know, but perhaps you'll excuse the conflation, knowing it's in the interest of promoting all such-like handcrafted work. I believe the sight of a new dry stone construction on the land is a sign of a healthy community. When loose stone is collected and arranged, conversations take place. Intercourse is initiated among people about their place on Earth.

Communality happens on a scale that is wholesome and sustainable. No one is left out of the conversation. The voices of the earth speak as loudly and confidently as those of human authority. My boosterism for the craft of dry stone is how I speak my concern for the future of the world. Handling stone is a way to pay attention to the Earth, its water, air, and nonhuman inhabitants. It's a good way to show care for one another as well.

The internal principles that hold a dry stone wall together have developed naturally, to their proper proportion, over time. The comfortable balance of logic, strength, and scale found in a well-built wall is what defines its beauty. One does not need to personally lift the stones into a wall to appreciate the beauty but it should be remembered that someone, in fact, did put them there. For the builder who brings a wall into being, that process is fraught with physical risks. All those who make their living sparring with the elements, whether wall builders, loggers, farmers, or fishermen, engage the physical world to the fullest, enjoying its pleasures and facing its dangers.

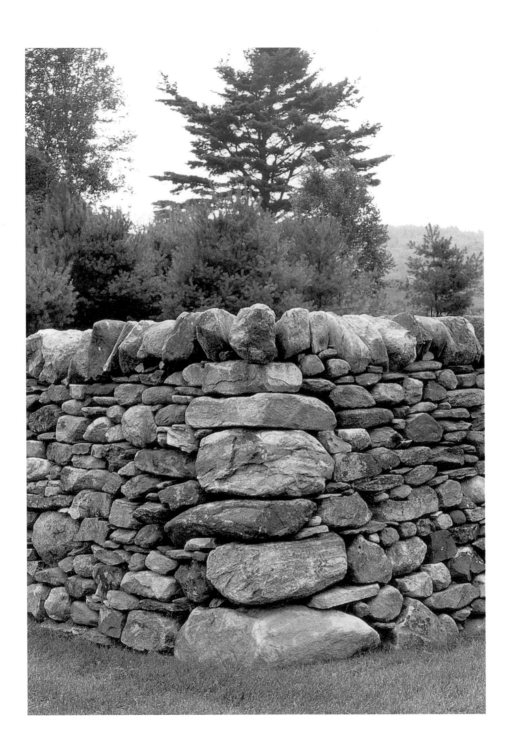

GARDEN FENCE

SCREENWRITERS TRY TO WEAVE BACK-stories into the fabric of their scripts. Backstories add depth to character portrayals and thicken plots. When Susan Richter and her screenwriter husband, Rick, began developing a plan for the future of their property they conceived a backstory for the land. They went prospecting in their imaginations for evidence of habitation from thousands of years ago. From the hill crest flanking their nineteenth-century farmhouse they mentally excavated tribal hut rings, remnants of fortifications against Viking invasion, and ceremonial circles left by wandering Druids. By enlisting me to fabricate a collection of artful artifacts, the Richters hoped to elongate the timeline underlying their sense of place. The arrangement of dry stone structures would also become the artifice for locating and establishing garden plots on the property.

The first manifestation of whimsy to emerge was the Garden Fence. Imaginatively, it was a pound used for keeping livestock by some early settlers. Literally, it came to life as an enclosure for Susan's berry bushes and

vegetable patch. Instead of keeping livestock in, the fence keeps wildlife out. The high, solid walls deter deer from leaping over and woodchucks from burrowing through to the rows of beans and broccoli. They also block the north winds that whistle up the valley and divert the frosts that slide down from the hills.

From a quarter mile down the driveway the straight lines of the wall stand out against the soft curves of the surrounding landscape. Viewed from a distance, the wall's form has a strong presence even before its constitution is revealed to the eye. The stone that makes up the wall has its own story. It was hand collected by the loader-bucketful from the remnants of old field walls and discard piles on the property. From the bucket the stone was handled directly onto the wall. During the three months I spent constructing the one-hundred-yard-long wall I was fixated on the stone. As soon as the stone became wall-structure its potential was exhausted, and consequently my interest in it was expelled as well. Now as I drive by, I clearly see the wall as a single entity, independent of its stone, and its maker.

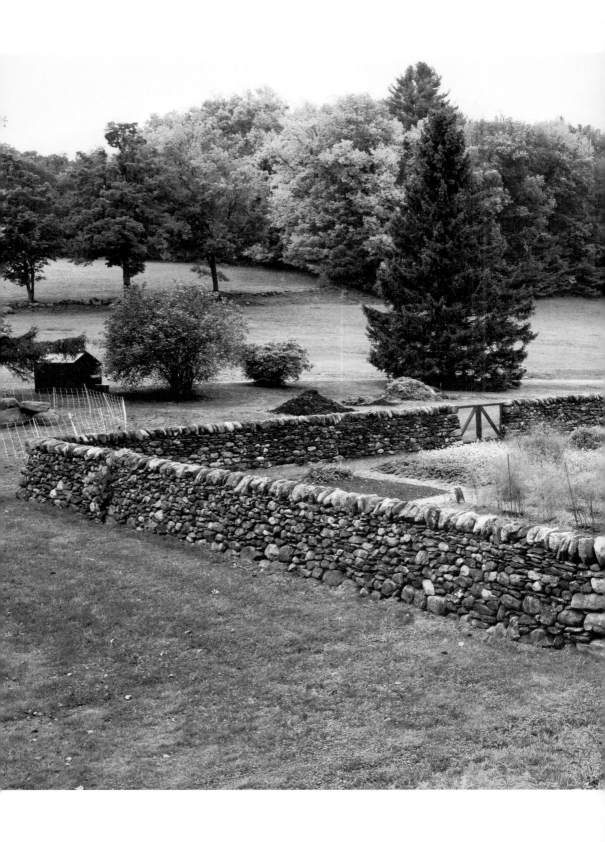

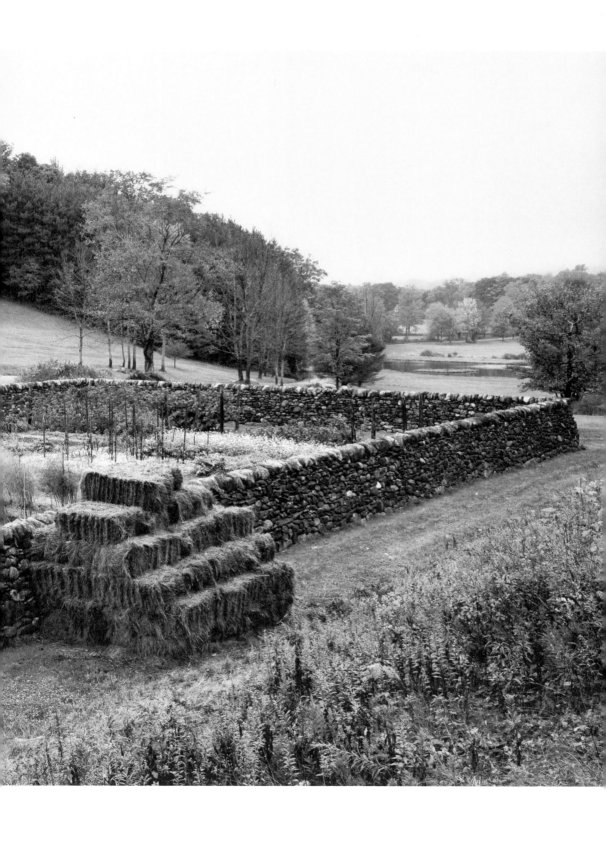

Every stone gets to its place on a wall in its own way. No two stones are alike. While their differences in weight and shape may be clear and definable, their pasts separate them more subtly and profoundly. Their formation in the earth's crust may have come millions of years apart. The disparate forces that fractured them into singular pieces and the travails they experienced within the ebb and flow of many ice ages are unfathomable. Once in place on a well-built wall, the character of individual stones blends together to create one coherent, readable line on the face of the earth.

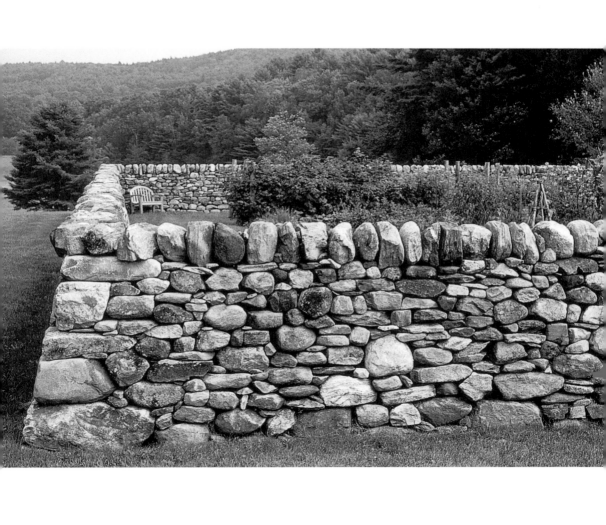

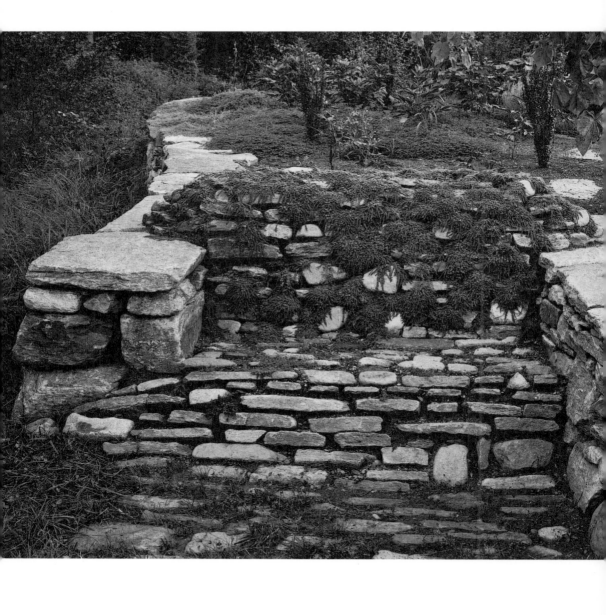

SEATS

GEOLOGY WAS THE LAST THING ON MY mind when the big block of Townsend stone tumbled from the dump truck at the Richters' building site. I didn't ask myself when it had been formed, or how. I just knew what it would be good for and that it was destined for a distinguished place in the design of their outdoor environment. The single piece, perfectly fractured by nature into the shape of an overstuffed chair, was given a room of its own in the archaeological fantasy that is their front yard.

Seating is a culturally complicated, simple necessity. My best successes in making outdoor seating have been a result of letting stone speak for itself.

The invisible power of an empty seat is the human form that's missing. An unoccupied chair is a reminder of someone not there. Its contours are full of connotations. A throne can symbolize the royal struggle for control of a kingdom. Or it can be the people's prideful place of honor for a beloved queen. In the cottage of the Three Bears, the rambunctious Goldilocks finds a chair that "feels just right" and takes her timeless place in folklore when Baby Bear's chair breaks to pieces under her weight. An empty chair is also a reminder that, in our turn, we too must give up our seat. Indeed, the appeal of the game "musical chairs" is in the chance to keep our seat after the music stops. We can continue to play the game as long as a new chair can be found. I, myself, certainly don't want to be caught standing when the music ends, so in an attempt to postpone the inevitable I keep making new seats. I felt like a genius the day I discovered the "La-Z-Boy" in my wheelbarrow. Just by

tipping a large wheelbarrow from its front wheel onto the ends of its handle shanks it becomes a surprisingly comfortable recliner.

Sometimes a design will call for specific materials. Other times a material itself is the design. A chair can simply be a "found" object, recognized for its perchable pleasures. After the comings and goings of ice ages have had their way in rounding and smoothing a granite boulder it will sometimes crack apart, like a halved hard-boiled egg. The shear planes of the cleft surfaces are in sharp contrast to the soft curves of the bald hemispheres. Two halves from two different boulders were combined to make a trailside seat on Jill and Kip Record's property.

I've often thought that a truly luxurious outdoor chair would be one form-fitted to the curves of a person's back and legs, especially if that chair was upholstered in a fabric of living thyme. When I was looking for an interesting way to finish the end of a retaining wall in Will Ackerman's garden, the couch idea came back to me. The construction is a "Dagwood sandwich" of stone and dirt. As soon as I was done building, thyme transplants were plugged into the soil seams. Eventually, the stone will disappear under a thick mat of thyme, and the seat will become a sun-warmed, aromatic pleasure spot, perfect for a summer's day snooze.

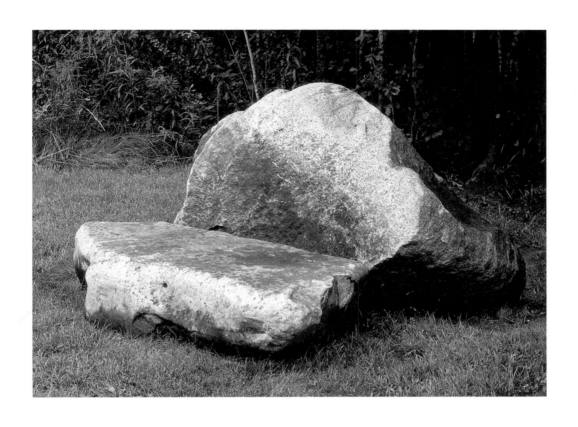

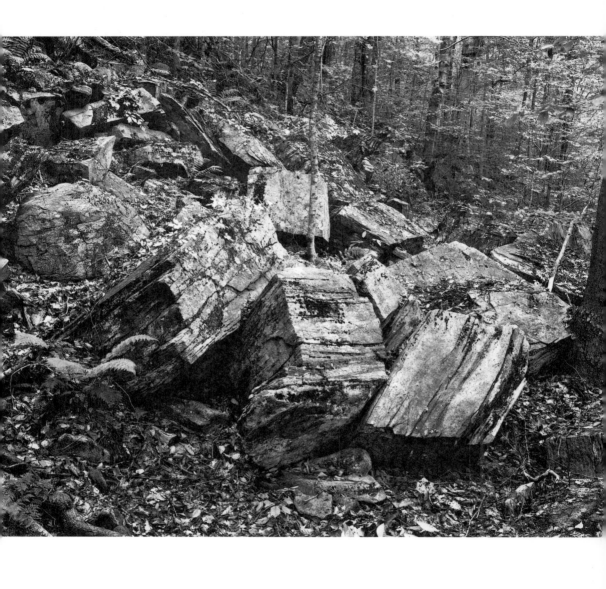

GATHERING

THERE ARE TIMES DURING MY YEARLY STONE GATHERING when the dump trucks roll down the highway to their destinations filled with bounty, the Morooka transporter trundles up and down the mountain track with ease, and the excavators (one at the top of Hemlock Ridge and one at the roadside landing) lift and load at a steady pace. But those hours are rare and fleeting. Better to admit that a day of gathering stone is to practice a contortionist's trick—bending to the intractable, twisting around the immutable, and bowing to the inevitable. It is a state of being in constant and continual adjustment to the prevailing field conditions. To seek out, collect, and transport a goodly amount of building stone requires a complication of men and mechanical devices that can reach epic proportions. And so, the wheels are set in motion. The stone is purchased from the landowner and the gathering takes place once a year, for two to four days, depending on the degree of difficulty in keeping the multitude of wheels turning.

Archie, his brother, Win Clark, and I began gathering calciferous mica schist from the ridge two decades ago. The challenge for me has always been to keep myself supplied in stone for wall building work. For them the challenge has been to get the material down off the mountain. There are easier ways to procure stone; calling a quarry and having it delivered is one obvious option. But it's just not the same—the stone or the experience. Going up into the woods assigns a value to the stone that can't be gained by any other means. They are discovered in a state of innocent repose, all supine, snuggled together on the forest floor in peaceful splendor. My wish that they remain undisturbed has never been as strong as the itch I've felt to build something with them.

On one such adventure, Win and I headed into the woods with the excavator and Morooka. At the top of the ridge the dark evergreen woods were clear of underbrush. Sharp ridges and smooth domes of ledge poked up all around, and by their sides or at their feet were the caches of loose stone. Some were in tumbled disarray, while others looked to be in the process of detaching themselves from the outcroppings, like petals falling from a bouquet of roses. Spatterings of lichen mottled the stones' surfaces, and patches of spongy moss grew from the cracks between them.

The fingers of the excavator bucket reached out and slid through the air over the slumbering slabs, dropped down into piles, and hoed up a paw full of stone. Without complaint the stones rolled into the dump body of the Morooka and began their journey down the mountain.

The mile-long road was steep in most places and extremely so in others. I jounced over boulder tops and knobs of ledge. Making the trip down the mountain with four tons of loose stone perched behind the headboard was worry-making enough, but it was actually the uphill battle that required extra finesse. The engine was revved to two thousand rpms for the uphill climb. I had hearing protection, but there was nothing to soften the pounding my backside got through the thin plastic seat. With both hands on the steering lever that controls the direction and momentum of the tracks, I couldn't always fight back when the branch of a beech tree slapped me across the face.

Keeping the Morooka pointed in the right direction required all my attention, even though it was only traveling at the speed of a fast walk. The machine was turned by breaking one track while the other continued to spin. Turning, while climbing, meant momentum was sacrificed for every change in direction. The steepest sections were only scaled by the employment of maximum forward motion. If the Morooka didn't make it up a slope and had to be backed down it could slip crosswise to the trail fall line and begin an uncontrollable slide.

The last grade on the uphill climb was the worst. It was a canyonlike area with a vertical ledge wall rising on the right side and a dirt bank rising on the left. The good news was that it was impossible to fall off the sides. But at the bottom there was a bend in the roadway and a perilous twenty-foot

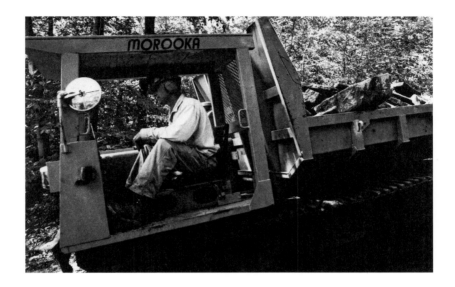

drop-off. The precipice was in the back of my mind every time I started up the last grade.

I made it halfway up the hill when the Morooka lost traction. I stopped it right there and set the hand brake. In years past when we had this problem Win would use the excavator to pull the Morooka up the last bit so I wouldn't have to risk backing down to try again. From up above Win heard that my forward motion had stopped and came to my rescue. He paddled the excavator to a spot slightly below the brow of the hill.

With his bucket curled over the headboard behind my cab Win began to draw the Morooka forward. I released the brake, but instead of moving forward the Morooka *and* the excavator began to slide downhill. Win couldn't put the hoe bucket to the ground to stop himself because it was suspended behind my back over the dump body of the Morooka. I didn't have to think twice about what I needed to do. I yanked on the lever to beat a retreat. I didn't have a chance to dwell on the fact that twenty tons of excavator was ten feet away and chasing me down the hill. I looked over my left shoulder to try to stay in line with the roadway. I glanced forward once to see an expression of alarmed concern on Win's face. We were in open, glassless, operator's compartments, like bumper cars at an amusement park. As the

distance between us grew I heard a loud noise and was temporarily brought up short. The bang was caused by the steel headboard behind me crashing into Win's boom and hoe bucket. It was like having a cathedral bell rung next to my head. He had the excavator in full-throttled reverse, attempting to stop or at least slow his slide, but it didn't help. Just as he began to get a little grip, my flight away caused the headboard and bucket to come crashing together again, jerking him forward. After what seemed like a lifetime, Win dropped the bucket down hard on the back end of the dump body. It stopped my retreat and gave him an anchor point. We sat looking at each other, astonished by our surprise ride and our apparent good luck.

I was just beginning to relax when I experienced the oddest floating sensation. I felt like I was in the basket of a hot air balloon. The ground was falling away around me, but the Morooka wasn't moving backward. I had a sickly feeling about the drop-off behind me and how close I'd backed to it. I punched the steering lever forward, but nothing happened. Looking up, I saw that the excavator boom was nearly in contact with the roof of the cab.

Win was in the process of collecting himself as well. As he sat across from me with his hands still clamped to the controls of the excavator he unconsciously pushed the boom down. The bucket pressed harder, the rear end of the Morooka sank lower, the front end rose, and I was taken on my inexplicable aerial ride. The precipice was still fifteen feet behind me and had nothing to do with my vertigo. I pointed a finger above my head toward the boom. Win laughed, realizing at the same moment what had happened, and eased back on the controls. The Morooka settled back down to earth. We untangled ourselves. Win spun around and clawed his way back up the hill, roughing up the road surface enough as he went for me to climb, without further incident, to the top.

Having stone to build with is the reason to go on Hemlock Ridge in the first place, but I've come to understand that our daily business on the mountain is that of beating a path over, under, or around the obstacles we create for ourselves. The thing that seems to keep us safe from danger is our singular quest: getting the stone out. We don't stray into harm's way out of ignorance; we go there purposefully.

BRANCHING WALLS

AFTER A WEEK OF GRUBBING ALL MAN-
ner of stones from an old fence line, chucking
them into the bucket of his tractor, and deliv-
ering them to where I was building the dry
stone sculpture in his front yard, Chris Dayton stopped to save out one
cream-colored stone and asked me to have a look at it. It was long and thin
with wavy contours. The smooth curves invited a caress. I cradled it in my
arms like a newborn child. Chris suggested I flick a fingernail at it to hear the
sound it made. "It rings like a bell," he said. Sure enough, the hard limestone
piece "pinged" like pot metal. The soft, warm exterior surface concealed a
heart as cold and tight as midwinter lake ice. We marveled aloud at the geo-
logic confluence of events that must have gone into its making, and the little
miracles that kept it from shattering to pieces along the way.

The stone was a talisman, an indecipherable relic from the earthly trea-
sure tombs beneath our feet. Amid thousands of other stones he'd handled
in gathering material for the sculpture, this one jumped out at Chris. Its
natural form was unique because it had meaningfulness. It was as though its
existence was due to some long-forgotten human endeavor. As I considered
the strong attraction I had to this stone I began to understand something
about my aesthetic consciousness. The stone seemed to suggest that the
greatest beauty in nature is that which looks most like a human interpreta-
tion of nature. In other words, I wished I'd made it myself.

How could the form I was making with many stones match the beauty
and mystery of that one stone? It was the force of humanity coming through
nature that made that one stone a prize in Chris's eyes. My creation could

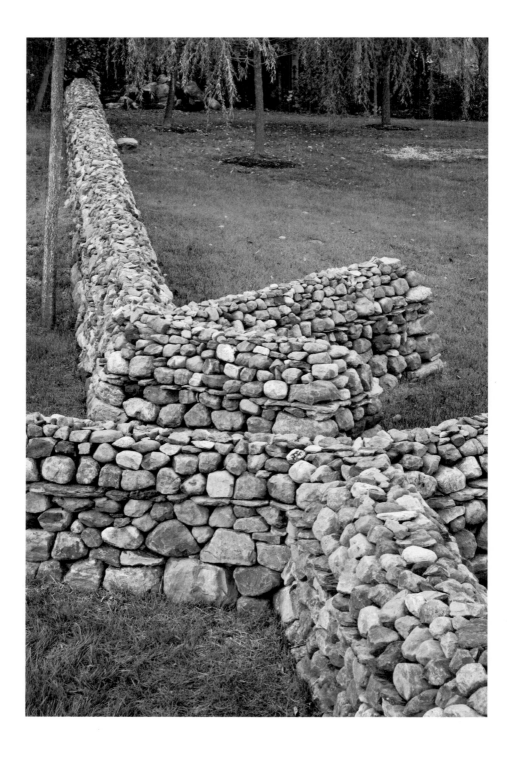

have beauty and significance if, in the end, it appeared to have been made by the forces of nature coming through me.

The plan was to pattern the shape of the sculpture after the growth of tree limbs, the way they fork and move inexorably toward daylight. The two branches of the piece began side by side but developed different shapes in response to each other's growth. They shared ground, and space flowed around them. Random courses of purple sandstone appeared out of the undulating earth and rose to a common level. There the branches were banded with thin sheets of shale. Like a distinguishing layer of petrified sediment in an ancient seabed, the shale separated the structural bases of the walls from their broad, crowning copes. The copes, or caps, became long mounds, heaps of small stone, like drumlins left behind after the last Ice Age.

Chris did all the grunt work of collecting the stone that went into the environmental art piece I constructed on his Cornwall, Vermont, property. He said the experience changed the way he looked at his native landscape. The old stone wall remnants that dot the fields and forests, formerly over-looked by him, have become major features of his new perspective. He now seeks them out as reference points in his understanding of the land.

One stone from his long days of gathering didn't make it into the construction. Chris's son, Charlie, was so taken by that peculiar piece of limestone that he rescued it from the stockpile, brought it into the house, and placed it on the mantelpiece over the fireplace. There it lies in perfect repose, an antique figurine sculpted by nature's hand, in accord with humanity's script.

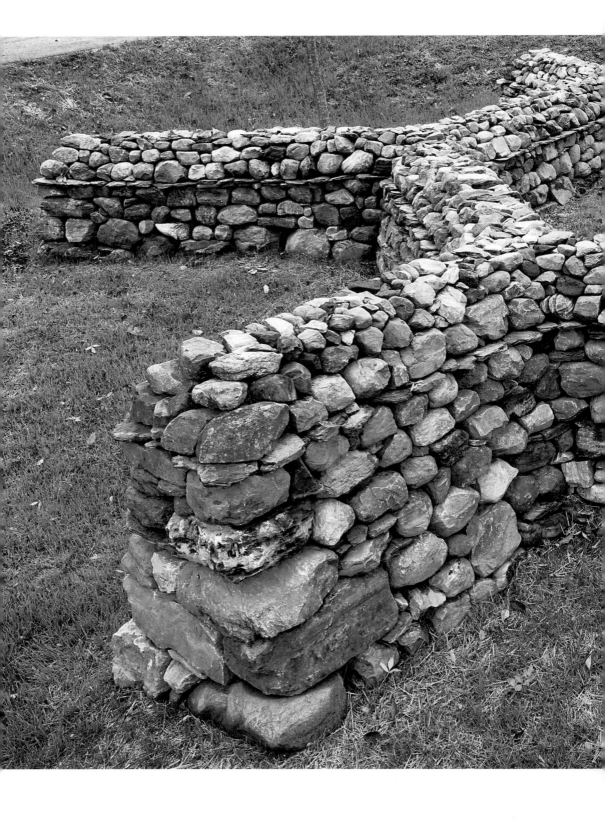

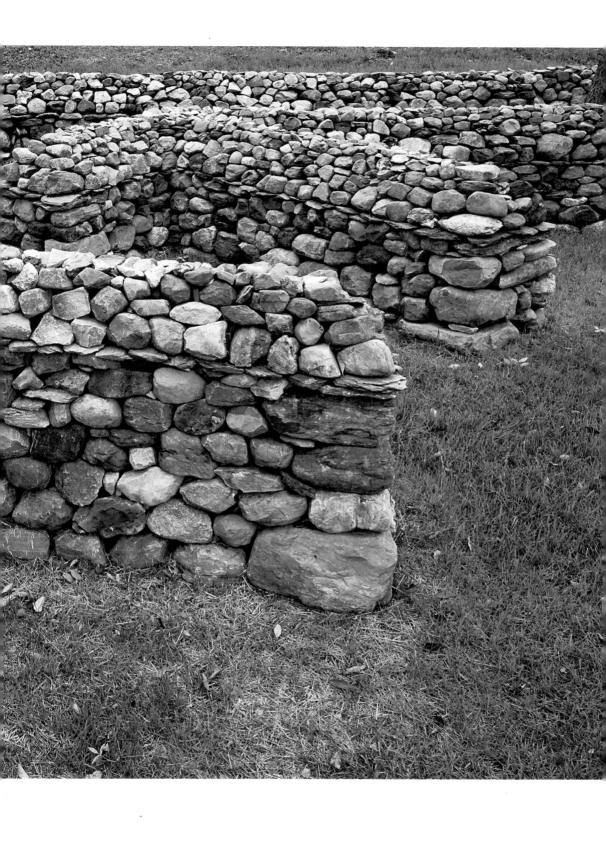

TIDES OF STONE

WHEN VEGETATION RETURNED TO THE LAND THAT IS NOW New England after the retreat of the last Ice Age it slowly created new soil over the glacial till and bare bedrock. For twelve thousand years, forest litter decomposed and mulched itself into humus. Season after season the soil incrementally built until it was a lofty four feet deep, even on the slopes of Vermont's Green Mountains. When European homesteaders cleared the virgin forests and began cultivating, the topsoil was light and free of stones. It wasn't until erosion cut into the opened ground, and livestock compacted the soil, that stones began to appear. Winter frosts drove deeper into the exposed landscape and lifted loose stones to the surface. Every spring the farmer's plow turned up more and more stones. They were tossed onto stone boats and dragged behind ox or horse to the edge of the fields. There, the first crop of the year was turned into a dry stone fence.

The stone fences served their purpose well in the farming communities for a few generations, but forces from within and without eventually brought most of them to a state of disrepair. The five-foot-tall, stock-proof, dry stone fences of the early 1800s had, by 1900, shrunk and become three-foot-high stone walls. Over many seasons of exposure to the elements their bases had spread apart and sunk into the ground, sod had built up around them, and the stones that had once defined their crisp top line had toppled and tumbled. The animals they were intended to confine also played a part

in reducing their stature, with agile sheep attempting to scale the walls and laconic cattle using them to scratch their behinds against.

After barbed wire became widely available, farmers were less apt to take the time to repair their stone fences. They opted instead to string a strand of wire above the remaining top stones of the broken-down walls, restoring them in a matter of hours to the status of stock-proof fences.

By the mid-1900s farmers had given up entirely on stones as fencing material. Multiple strands of barbed wire stapled to wooden posts ran parallel to the obsolete old walls. Where farmland reverted back to forestland the walls were further disturbed. Dead trees and harvested timber crashed down on them from above. Thick root growth heaved them from below. The stone walls were disassembled into stone piles. The collection of stones that were once two-foot-wide, five-foot-high fences became two-foot-high, five-foot-wide mounds.

As the walls became piles, evidence of their original handmade structure all but disappeared. In less than three centuries, stones were raised up out of the earth and built into fences, the fences devolved into obsolete walls, and the walls spilled themselves back across the ground. Before many more centuries go by, the pile of stones will be thoroughly remixed into the earth's ecological stew.

DRY STONE ANTIQUITIES

WALKING THE LANDSCAPE OF WINDHAM COUNTY, ENCOUNTERING a piece of work made from loose stones, it's difficult to get a fix on the time of its creation. Evidence that might date its construction is elusive. Because there's nothing in its makeup to rot, rust, or peel away over time, an old piece looks not much different from a freshly made one. The stones they're both made from are equally ancient. When I come upon an old wall or foundation in the woods I can guess its age, but there's no way to tell for sure just by looking at it. Written historical records on the subject are scant.

While I enjoy discovering the facts behind the old dry stone constructions, I'm equally intrigued by their absence in historical accounts. Encounters with the unknown unlock the doors of the imagination. I am thinking especially of one enigmatic stone barrow just across the West River in the town of Putney.

The hole is on a high point in the woods, away from any other evidence of past human habitation. Some say it was a root cellar, others, a hiding place on the Underground Railroad. Archeoastronomers are of the opinion it may have been used as a prehistoric observatory. Its entrance is so inconspicuous, if you didn't know what you were looking for you might walk right past it. The earthen bulge in the side of the hilltop is not unlike the surrounding natural topography. The only indication of something out of the ordinary is the arrangement of flat stones that cap it. When the central

stone is slid aside an opening into the ground is revealed. It's just big enough for a person to drop through and then stand on the dirt floor five feet below. The space is large enough for a half dozen people to sit with their backs against the stone wall that circles the interior. It's dry inside. The corbelled slabs that form the roof shield it from ice and rain.

Much has been made of the little structure on Putney Mountain and others around New England similar to it. One theory speculates that the construction was done during some pre-Colonial period as a kind of clock, a device for tracking the yearly cycle of the sun as it rises each day over the eastern horizon, and marking the turning point from its southerly to northerly migration. The first beam of daylight on the morning of the winter solstice might have shone through the opening and struck the western wall of the little room at a prescribed point. No one knows for sure.

Until archaeologists and historians agree about the origins of New England's enigmatic dry stone structures the rest of us are free to invent our own scenarios. I like to imagine the chamber on the hill as Putney's first movie theater. An animal hide, with a pinhole punched through its center, stretched across the ceiling aperture would have allowed the chamber's occupants to watch the glowing image of a solar eclipse manifest itself on the floor of the darkened space.

In the floor of the Cistern is a small pool of clear water refreshed by a spring that spills out of a slit between two halves of a split boulder in the back wall of the construction. The seven-foot-tall, vessel-shaped object has an opening at its top and on its east side, exposing the cool, moist interior walls to view. The little grotto was created simply for fun, a water feature to decorate the landscape. But I wonder what will be made of it, many years hence, after all memories of its creation have vanished. Maybe it will join the other objects scattered around the county that are of questionable origin.

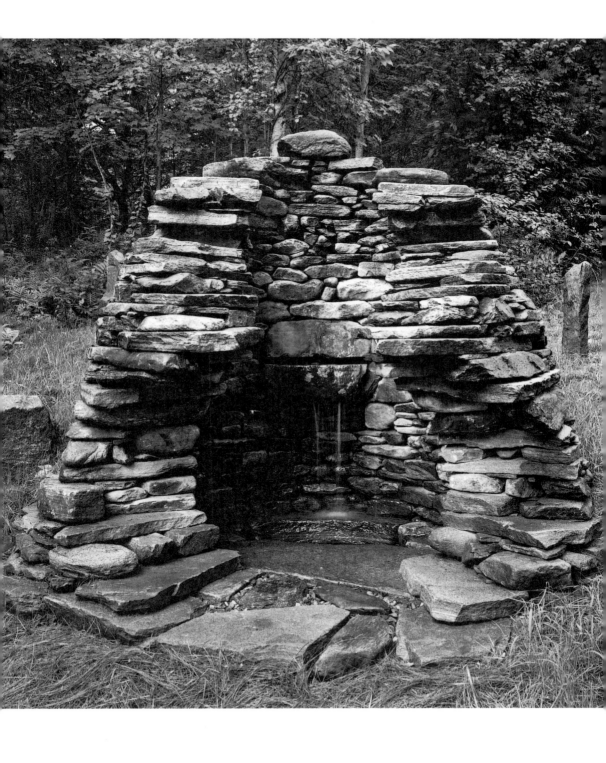

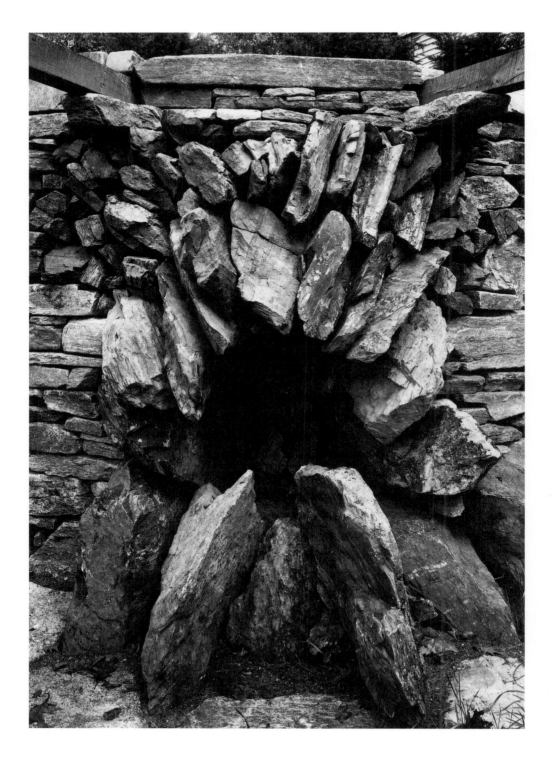

MYTH MAKING

OUT OF ALL THAT GETS FORGOTTEN GROW STORIES TO fill the ever deepening void. The complete inspiration for a work is not known until long after it's been made. Over time, the fact-littered history of the building process fades and is replaced by a freshly minted awareness and viewpoint. The experiences between the time a thing is made, and when it is looked back upon, morph into a creative intelligence that imbues the object with the power of prescience. It's as though it came to being when it did in order to be there in the future, when a place for the memory of new experiences would be vital and welcome.

The ideas that initiate a piece of work in dry stone, and the processes that take it from excavation, through construction, to completion, hang over the work like decaying fumes until, eventually, they dissipate. And all that's left in place is the overwhelming and everlasting presence of the piece. The discussions about siting, access, footing, proportion, scale, drainage, stability, materials, tolerances, and grades are what the piece is made out of, but not what we are left with. What remains becomes an open receptacle for dreams to fall into. A mass of rock becomes fertile ground for myth to grow.

The piece of work drains free of former associations and begins to take on a personality. It is recognized as being able to carry more than just its own weight. Because it has proven unquestionably that it can stand the test of time, it is entrusted with timeless fantasy. And right then and there it begins to open itself to interpretation. Into opportunity pours possibility. Out of possibility a selection is made and an ensemble created. Impressions, reflections, emotions, recollections, and dreams all mix and match until they settle into the piece, fill all the cracks, and infuse the mass with myth.

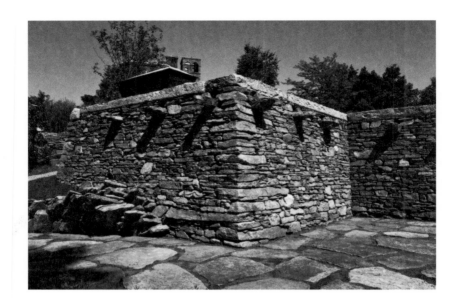

In the mid-1980s I began work on a property across the Connecticut River in Walpole, New Hampshire. I didn't know it then but the garden features and follies I was to build for Teddy and Peter Berg over the next twenty years would become my definition of living myth. The high walls below their front lawn are a case in point. I can now walk past the fabricated ledge outcrop at the base, the empty beam-sockets high along the top of the wall (pictured above), the deeply cut stepway (opposite), the jagged-edged cavern (page 60), and see mountainside rock slides in Norway, defensive castle crenellations in Italy, a twisting alleyway in Switzerland, and the gruesome countenance of a Finnish fairy tale character. Because I had the overseas experiences after the pieces were made, they have become a playhouse of memory, a theater for the mind. The constructions, in the wisdom of their age, have gained omniscience, because the future was foretold in their making.

While I don't believe, as Thomas Pynchon's "Sentient Rocksters" do, that rocks have thoughts and feelings, I do believe they hold a muscle memory of all their earthly experience.

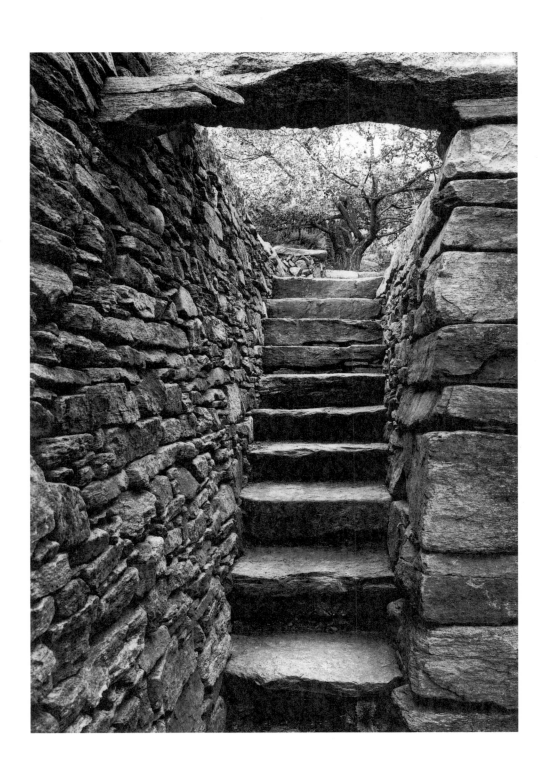

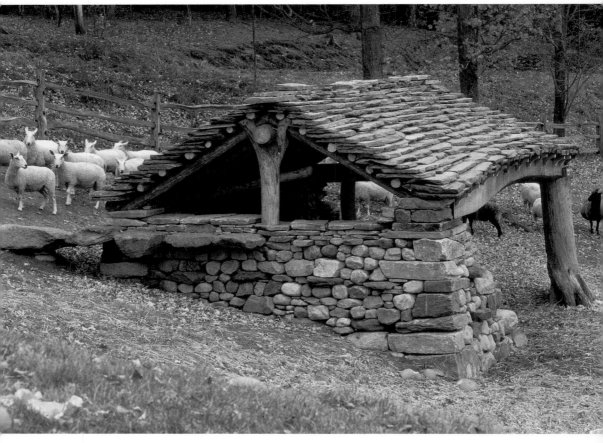

The Sheep Shed sits atop Rice Mountain's highest meadow, a fitting site for a structure inspired by a trip to the Alps of Switzerland.

SWISS STONE ROOF

 I'D GONE TO VAL LUMNEZIA, SWITZERLAND'S "Valley of Light," to meet Deiter Schnieder. I found him on a steep slope above the village of Vals instructing a walling workshop. The pasture grass was a vibrant green in contrast to the sprinkling of snow that lay on it. Before our meeting, Deiter and I had corresponded only by mail and phone. Our mutual memberships in the Dry Stone Walling Association introduced us to each other. His invitation to lend a hand with his workshop is what brought me there. The people in the workshop were young farmers, men used to navigating the tilting terrain of the region. By the time I arrived, broken sections of an old wall had been stripped out and the stone had begun to be reworked. Conversation among the participants was in a dialect of Romansh. I had to look for ways to contribute to the day that didn't require language.

At the midmorning break I straightened up from walling and took in the scenic surroundings. From that vantage point the village looked to be all rooftops, a mismatch of slanted planes blanketed in loose stone. The complexion of the town had changed dramatically from its appearance at the roadside. The buildings' wood-clad facades were barely visible from the hillside. The valley floor below had become a reflection of the stony heights above, a patchwork pattern of blues and grays. It looked as though flinty bits had broken off the peaks and fallen in random order along the banks of the rushing river. When it came time to get more stone for the wall I learned that my fantasy about the creation of Vals's rooftops wasn't that far from the historical truth.

One hundred meters above where we worked was a pile of stone. When

Deiter sent a man to fetch some pieces to supplement our supply I followed along. There was no road, no trail, not even a path, just a steep slope full of pasture-grass humps and bumps. I anticipated carrying, by hand, one or two stones at a time from the pile to the worksite. Admittedly, I've been spoiled by having power equipment at my disposal for moving stone. But even if I'd had my faithful front-end loader, it would've been of no use. The terrain was just too rugged.

Just as I resigned myself to doing a stretch of hard labor my companion flopped a big evergreen bough to the ground beside the pile. He pitched a dozen stones onto it. As soon as he lifted the butt end of the branch up as high as his hip the whole load started to slide downhill. He walked ahead, keeping control of the makeshift stoneboat by raising the butt to speed it up, and lowering it to brake. The fronds of slippery pine needles and the thin layer of wet snow combined to keep the bough and cargo smoothly gliding along. I loaded up a bough of my own and began freighting stone. The sled was propelled by the weight of its load. All I had to do was finesse it along.

I asked Deiter who the brilliant inventor of the tree-branch stoneboat was. He said it was just the way it had always been done around here. I took another look at the roofs below, the subtle variations in their colors and textures, the randomness of their coursing, and the whimsicality of their ridgelines. There was a touch of play to it all. Before, I only saw a mountain of human effort. After that I saw a different game.

In this construction created for Teddy Berg I can trace a direct line from my overseas travel to its germination and instigation. A year after my trip to Switzerland, Deiter came across the Atlantic to help me build the Sheep Shed. After I laid up the walls of the structure, Dan MacArthur cut and erected the timber frame that supports the roof. Deiter, Michael Weitzner, and I shaped the stones and laid them on the rafters. They are held on the slope by their own weight and nothing more, just like the stones on the roofs of Vals.

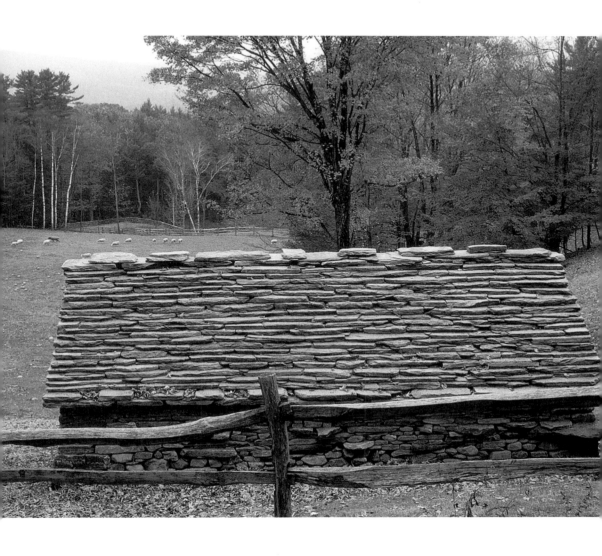

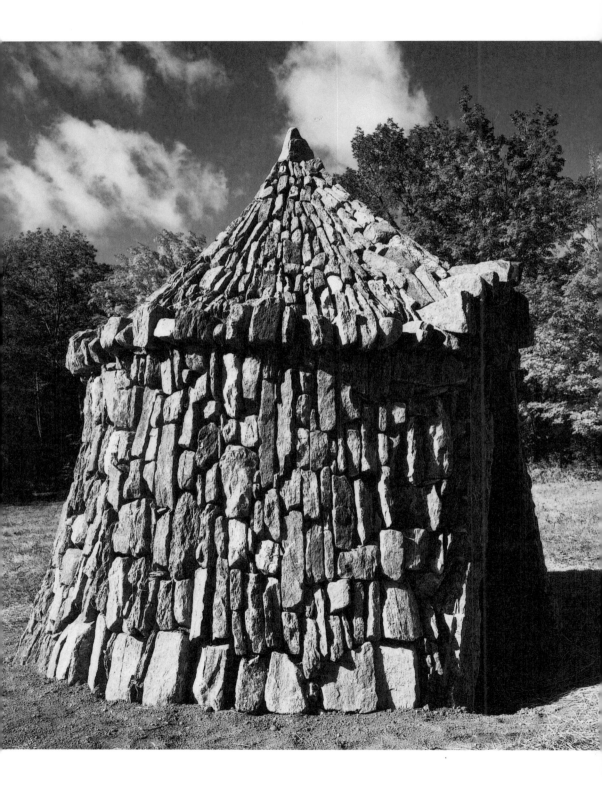

ARCHER'S PAVILION

 SMITH BROOK IN NEWFANE HAS BECOME a place of creativity for me. On the slopes of its watershed I've built thirty constructions on ten different properties. Overlooking the bogs and beaver ponds that form the brook's source is an old farmstead. I've been littering its fields and garden with works in stone since 1981. One summer I got the urge to try something different. Archer's Pavilion was the result.

In the "marks" was where a common man of medieval England passed his Sunday afternoons. With the sound of arrow feathers rustling softly behind his ear, he walked swiftly, bow in hand, quiver on his back, around a prescribed course, stopping only to plant his feet, draw a breath, and loose an arrow at the next butt—a target 250 meters away. On the edge of every village the scene was replayed, men and boys moving through a pastoral landscape, pausing occasionally to pluck the yew and then moving on. This was no sport. They were practicing a lethal art by order of the king. Bowyers were not part of England's regular army; they wore no armor and were paid only a pittance, but when brought together on a field of battle they became England's secret weapon.

The longbow had been in use for centuries but never with such killing effect as during the Battle of Crécy in 1346, where seven thousand archers fired a half million arrows, slaughtering as many as ten thousand adversaries. English casualties were only in the hundreds. Regular practice in the marks had developed the speed, skill, and accuracy needed to rain down death. The French army was unprepared to defend itself against this new style of warfare.

The refinement of craft that brings accuracy to a weapon creates a beauty

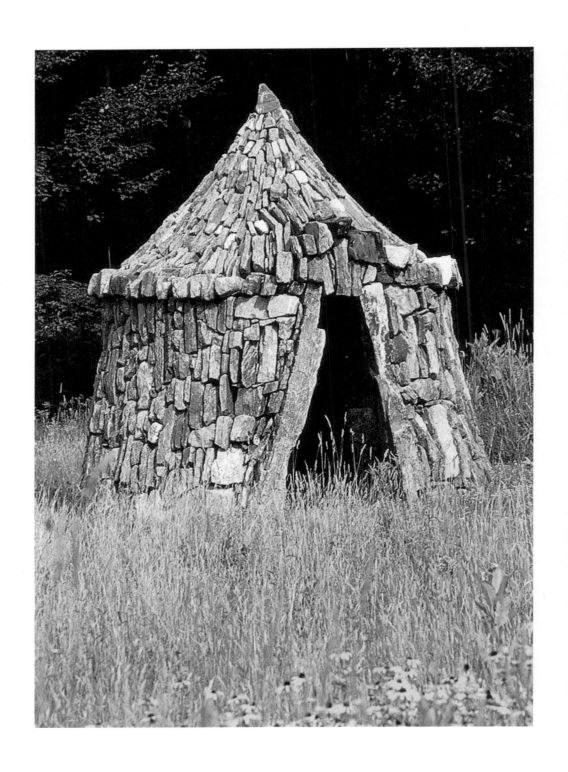

and perfection of form that is recognizable independent of the object's intended use. Bow carving and arrow fletching were, and still are, fine handcrafts. Many instruments of war are, on their own, beautiful things. When longbowmen were bivouacked along the road to battle they availed themselves of the comfort of a small tent. The archer's pavilion had a conical roof and sloping sidewalls. Thousands of these light shelters pitched on a greensward must have presented a pretty picture to the casual onlooker. It was just such a vision that gave me the idea of making an archer's pavilion of dry stone for Barbara and Ernie Kafka.

Having found a customer with a broad meadow and an even broader mind I collected some stone and set to work. The shape I was after was soft and round, but my stones were flat and straight. The contradiction in terms was solved by setting the stone vertically. The edge thicknesses of the stone conformed to the tight radii I was dealing with. And the lengths of the stone followed the curves that fell from top to bottom, giving the outline of the pavilion the look of draped fabric.

On a perfectly peaceful, early fall day I was halfway finished with the roof construction. The sky was bright blue, calm as could be. The only sounds to be heard were birdsongs and the tapping of my hammer. I was happy, content, feeling accomplished. It was only after the workday ended and I was heading home, listening to the radio, that I understood what had contributed to making the day special, why the sky was void of contrails, why it had been noiseless overhead. All aircraft in the country was grounded. The jet planes that normally crisscrossed the sky were no longer flying, since four of their number had been turned into arrows and loosed at our country's citizenry. On that day I had the pleasure to work under a sky not unlike one that may have lighted the work of a fourteenth-century waller but oh, mercy, it came at such a toll.

No doubt, for me, the Archer's Pavilion will always carry an association with 9/11. I'm glad to know though that others see it differently. I was told by a parent who drives past the piece every day that her young children call it the Tooth Fairy's House.

In a laboring life, ideas percolate up through the routine of a working day. Mental space opens and allows for inventive thoughts. Call it daydreaming if you wish, because it does proceed from a freedom of movement of the mind. Or call it meditation, because it also entails a form of focused concentration. Whatever the name, it's where mental play and physical work coalesce.

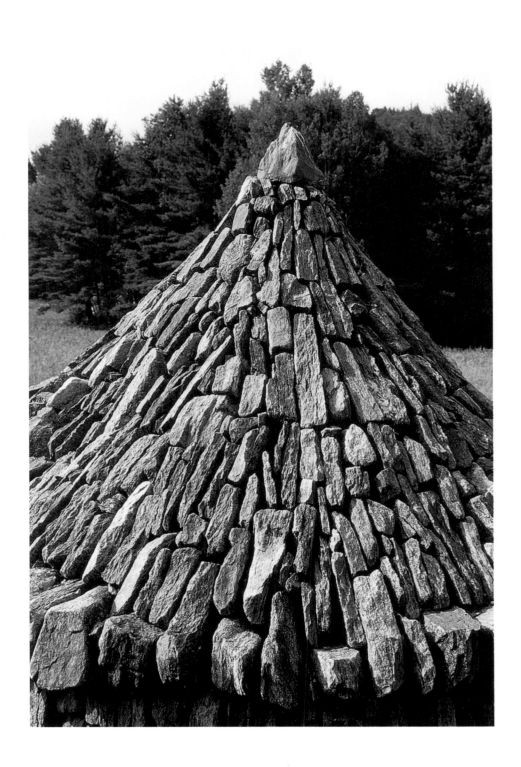

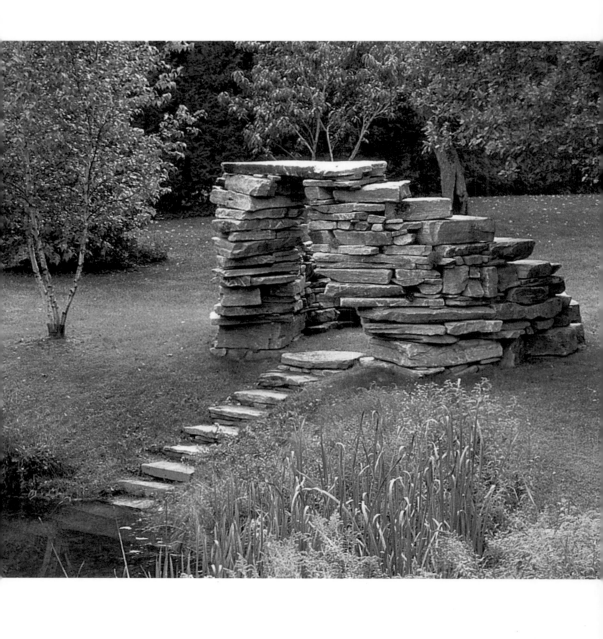

KINGFISHER

I FIRST ASSEMBLED KINGFISHER IN MY stone yard. Satisfied that I could, in fact, build a pair of twisting stairways, bridged at their top steps by a single long slab, I dismantled it, numbering each stone as I went, and trucked the parts eight miles up the West River Valley to the Prescotts', and reassembled it. The work was commissioned to commemorate Helen and Blake's fiftieth wedding anniversary. Recently, Kingfisher and its setting next to Smith Brook was the site of their daughter's wedding. Kingfisher is the name I gave the sculpture, as a nod to the bird that patrolled the brook each day I was working there, and to the memory of a friend whose too-short life I was reminded of by that proud bird.

For seven years Ed Kadlubkiewicz kept his blacksmith forge next to the stone yard at the bottom of my driveway. From the house I could hear the sound of his trip hammer repeatedly lifting and dropping, the heavy thudding of metal meeting metal. It drew me out and down the hill to watch Ed bring form to his vision. From the burning coals he would fish out a steel bar, lay its glowing end on the anvil, and swiftly shape it to his wishes with rhythmical hammer blows. It was my privilege to act as Ed's "striker" when he needed someone to swing the sledgehammer. Ed was completely absorbed in his process of creation, but he would stop from time to time to tell me stories of the deprivations he experienced growing up in Communist Poland. When he was a child, Ed, along with five family members, lived in a one-window, two-room apartment. He made his bed each night under the dining table. On Christmas Eve he and his siblings would receive their most eagerly anticipated present: an orange. Ed ate a section a day, making his orange last until the New Year.

A kingfisher begins its life by breaking out of a hard shell in an unlined nest at the back of a long, dark dirt tunnel. The stubby-winged bird, with a scissorslike beak and a large head crested with spiky slate blue feathers, takes its first flight from a hole in the ground and soon learns to scout along a length of stream, spy a fish, dive from an overhanging tree branch, and dip under the water to snap up a meal in its beak.

Even without knowing the particulars of a kingfisher's life there is something about the sight and sound of the bird that draws respectful attention. When I heard the voice of Smith Brook's kingfisher I always took notice and tried to catch a glimpse of the fleet bird. It's clear from watching one work its way from perch to perch along a wooded stream, and listening to its staccato cry, that the kingfisher holds dominion over all it surveys. It is fully aware of its surroundings while at the same time singularly intent on its purpose.

The fledgling kingfisher leaves its subterranean nest behind. Ed worked his way out of oppression with artistic expression. Out of darkness emerges the light of a life.

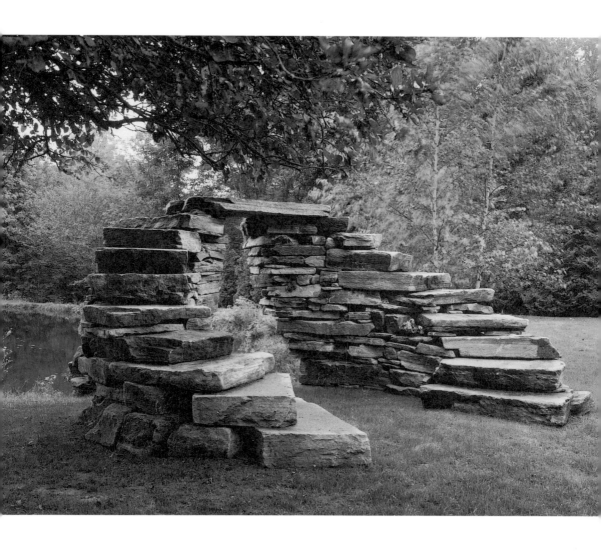

PRY BAR

IF I HAD TO CHOOSE JUST ONE TOOL TO TAKE TO WORK
it would be a pry bar. It can be thrust at the ground and used like a pickax
to dig, or employed like a jackhammer to pulverize a high point or crack
off a protrusion on a stone. It's a basic lifting device when used in conjunc-
tion with a fulcrum and a rudimentary shifting device for pinching a stone
along. A bar end can be dangled from the fingertips of one hand to check
the plumb on the cheek end of a wall. With a bar gripped in my hand like a
walking stick I move about my construction sites with confidence. It's the
staff of my working life. A good pry bar is a reliable consultant and depend-
able companion.

A day I forget to bring the pry bar to work is cursed until I go back for
it or find a replacement. I can get a lot done without it, but inevitably there
comes a point where a pry bar's leverage is what I need, and all I need. It's
often not a big shift that's required, just a skooch, but without that steel
point precisely placed where fingers can't fit and should never go anyway,
the stone won't budge.

The truer a bar stays to straight over its four-foot length the more effec-

tive its power. A bent bar doesn't translate energy to deed accurately. Forces go off in unintended directions, at unpredictable moments. With my full weight on it, a crooked bar can suddenly crank sidewise, jump off its mark, and send me sprawling.

It's axiomatic that the life led fullest will run closest to doing itself harm. I've plunged recklessly into tasks, allowing so-called expediency to overrun caution. Sometimes sheer luck has saved me. Other times it's been the word of a fellow worker that's gotten me through these episodes of stupidity unscathed. While I do have a collection of thin white scars on my fingers, mercifully, my digits are all still attached. A fact I attribute at least in part to Dick Hickey, a seasoned mechanic and heavy equipment operator, who knows the signs of impending catastrophe. More than once, while watching me jam my arm, up to the shoulder, into the dark recesses of a stone jumble in an attempt to retrieve the loose end of a chain, I've heard him drolly say, "Dan, don't put your fingers where you wouldn't put your face." And that's all I've needed to hear to save myself a trip to the hospital emergency room.

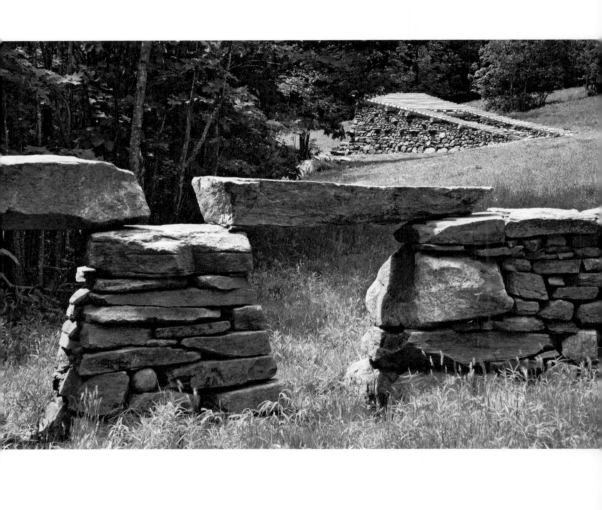

WALKING WALL

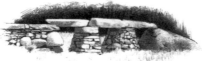THE MOMENT THE WALKING WALL was completed I saw before me a poetical work. Afraid to jinx the magic by looking at it too closely or critically, I didn't pause to ponder exactly what that meant or how it had been accomplished. The piece was simply a poem, that's all there was to it.

With every work completed since then I've looked to see if the experience would repeat itself. Sometimes it has but mostly not. It makes me wonder if such a precious feeling can be fabricated or if it's only the product of happenstance. I now find myself willing to examine the process that created the Walking Wall in the hope that such an exploration might increase my chances of experiencing some additional magic. Perhaps from its components I can extract a formula to apply to future projects.

1. The High Value of Low Expectations
Harvey Traison was a new customer. He asked me to take a look at his fifty-acre property on Wiswall Hill in Newfane and see if I could do something with it that would entice him to leave the house and take a walk. The undulant topography was host to a mix of mature hardwood and softwood trees. There were fields and views of distant mountains. In short, there was nothing not to like about the place. Whatever I might end up doing for him I knew I would enjoy spending my time there.

The property was part of an old farmstead, so there was an old barn foundation and other remnants of stonework concealed in the underbrush. I could become a local hero if all I did was clear brush from the old walls. I got busy with my clippers and chain saw.

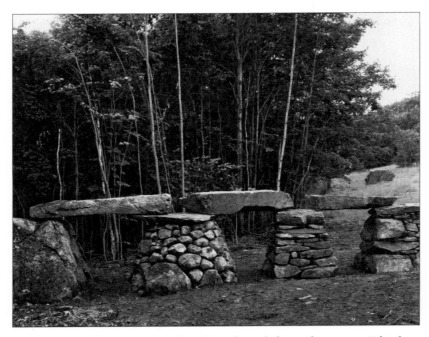

The process of creating one work produces the seeds for another to grow. Behind Walking Wall is the rock that inspired the Rock Shelter.

2. Potential Reveals Itself

Brush clearing allowed me to be a participant in the space. I was doing something useful while also being attentive to the surroundings. My imagination roamed around the place while my back was bent to the work at hand. Possibilities emerged in my mind, and right behind them came their limitations. Simple notions grew into grand schemes that deflated into building programs I could reasonably expect to accomplish.

3. Respectful Enhancement

The removal of the hardwood saplings and berry briars opened all aspects of the wall to view. Its dilapidated state became fully evident, as did its potential. Repairing the old wall would return its dignity, but I wished to give it something more. Sections of collapsed wall were rebuilt and height

was added to low areas. I finished it off with flat stones, sturdy enough to walk on. At the upper end of the field I added a stone ramp that led from the ground to the wall top. From there the wall became an elevated path through the tall meadow grass.

4. Finding the End in the Beginning

The clue for concluding the thoroughfare was found ninety yards along its length where a large boulder formed part of the wall. This immovable glacial erratic was very likely the reason the original builders situated their wall where they did. They aligned the wall to incorporate the stone. Just as brush and debris had been removed to reveal the wall, portions of adjoining wall were removed to give the magnificent boulder full exposure. But in order to include it in the walkway along the spine of the wall a bridge would be needed. So long as I was building one bridge I might as well build three, since that was how many exceptionally long stones I'd unearthed in the process of rebuilding. The trio would span nicely between the wall end and the boulder. All they needed to hold them up was a pair of piers.

5. Unmatched Pairs

In the process of taking down the wall sections that had butted up against the boulder I noticed that the stones were of two types. It seemed only fitting to use the round stones for a round pier and the square ones for a square pier. The materials suggested the shapes they should make.

Now that I've taken a look back I doubt that I will ever try to use my reflection to pattern a future work. The poetry of the Walking Wall is not in the details of its building process or in the philosophy of creation that the work inspired. I think I just got lucky that summer on Wiswall Hill to find the words for the music that was playing there.

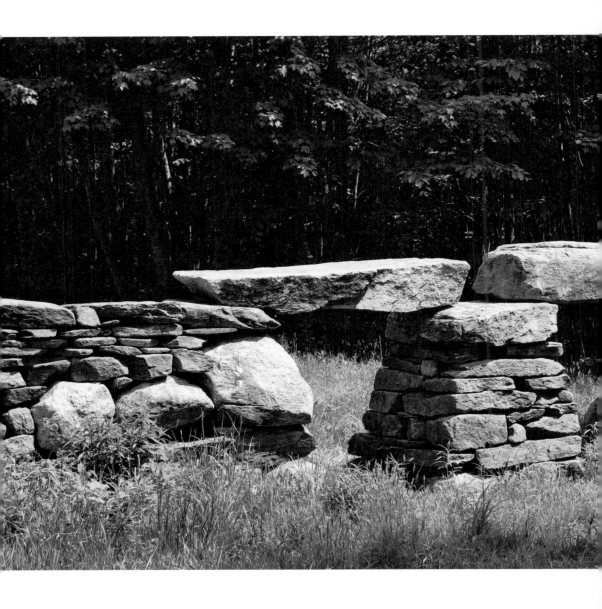

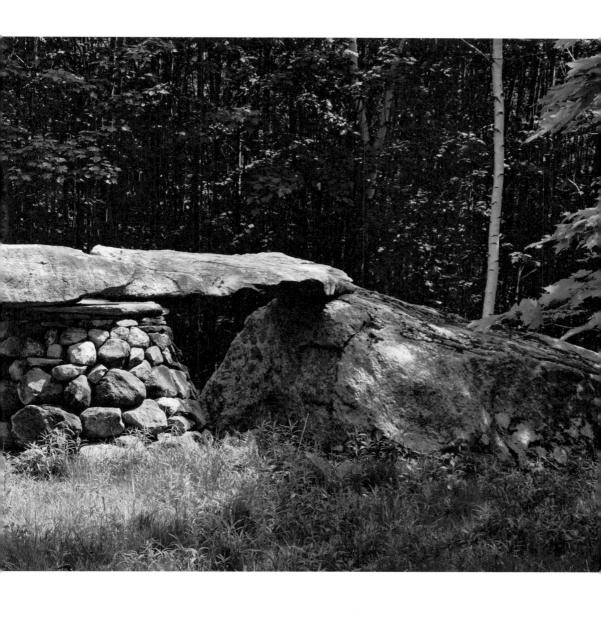

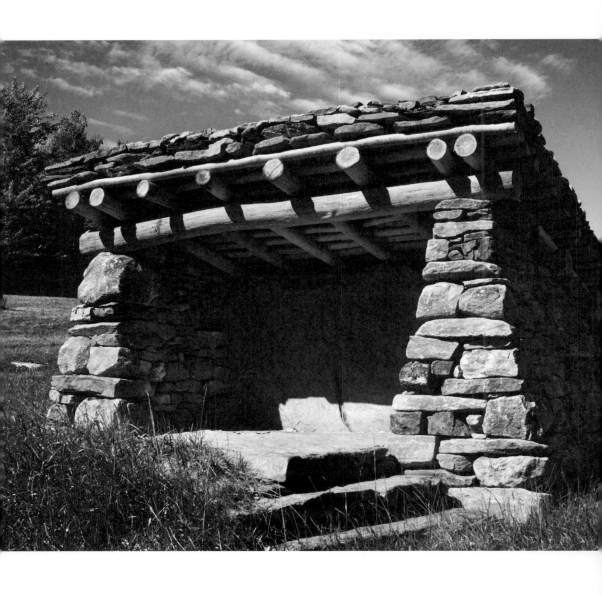

ROCK SHELTER

 WHILE SCRATCHING AROUND IN HARVEY Traison's meadow, prospecting for stone to build the Walking Wall, I unearthed a great slab of loose rock. It turned out to be more than I bargained for. I couldn't move it much, but I could tip it up on edge, so I planted it with its broad sides facing north and south. The stone stood erect through the seasons, bathed in moonlight or covered in snow, until I thought it was time to build a shelter for it.

Just inside the woods that border the field was a large pile of stones collected by a pioneering homesteader. Stones, turned up by the plow, were picked up and cast off the cultivated land. Tons of stone accumulated over the years. The farmer's bane became my bounty. I gathered it up and built the shelter walls and roof with it. The second resource was the woods themselves. Young trees grew thickly there, tall and limbless for half their height.

With the addition of some steel fasteners and a roll of waterproof sheeting, peeled timber poles and loose fieldstone combine to embrace the standing stone, sheltering it from the elements. Not coincidentally, the slab helps to hold up the roof frame and roof stone. And the roof stone holds down the rubberized sheeting that protects the timbers from rain and rot.

From a distance the Rock Shelter looks like it could be a camper's lean-to. On closer inspection it becomes clear that there's really no room for people inside. The interior is filled with the rock slab. The only camper under the lean-to is its permanent resident. Although we don't have to care for things that are indestructible, when we do give them special consideration they become something different in our eyes. With that changed perspective our view of ourselves is cast in a fresh light as well.

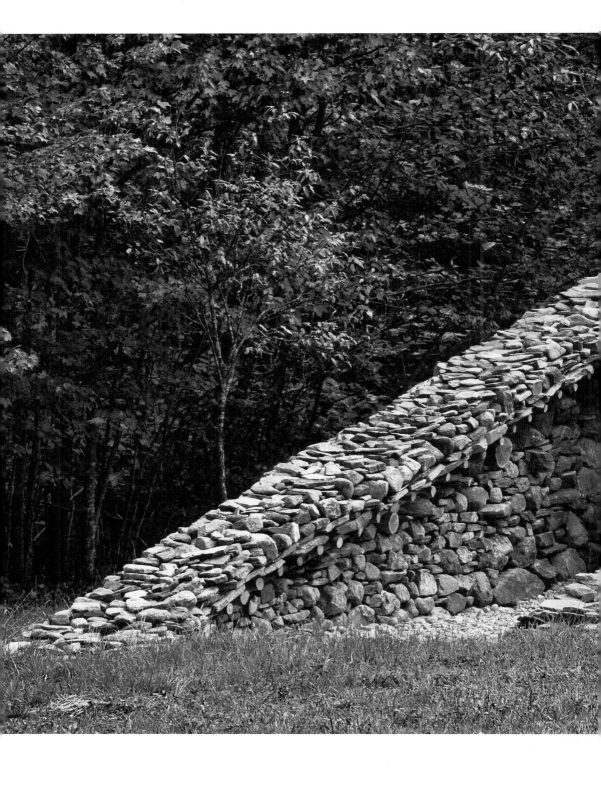

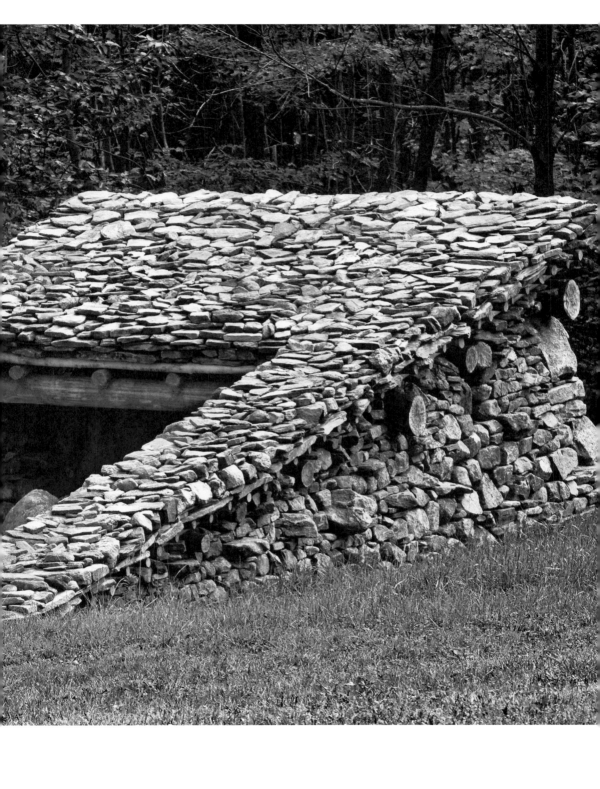

CENNINA

I WAS BORN FIFTEEN MILES FROM MY GREAT-GRANDFATHER'S birthplace. My family didn't stray much outside the Brattleboro area. An exciting trip for my brothers and me growing up was riding in the backseat of the Plymouth to the Saint Lawrence Seaway, on the Canadian side of Vermont's northern border, to watch ships slowly rise and fall in the locks. Sailing on one of those ships across an ocean wasn't even in the realm of dreaming. It's not that we weren't an adventurous family. We just did our exploring locally.

After breakfast, our mother shoved us out the door for the day. If it was raining we played in the garage or on the porch. Our neighborhood had a surplus of kids who were also outside a lot. We had a network of foot trails through the woods that connected our houses and followed the course of Whetstone Brook. Every ledge overhang and swamp hollow was investigated. We gave names to the places we discovered: fireplace rock, dipper spring, porcupine tree. In wintertime we shoveled snow for dimes and dug caves into the piles for fun.

Our section of town was called Swedeville, named for the immigrant population that settled it two generations before we moved in. Organ manufacturing was Brattleboro's biggest industry and drew skilled woodworkers from Scandinavia and other parts of Europe to work in its factories. Many of our playmates were the grandkids of those immigrants. The workers' housing was modest but well built. A German-speaking family of Mennonites turned an old carriage house into a summer Bible school. A wizened grandmother from Sicily with a straw basket on the crook of her arm, her face shrouded in black lace, regularly stalked the woods, hunting for wild mushrooms.

I left Swedeville for the wider world by way of art school in New York City. The hum of the city was exhilarating but it was hard for me to keep up with its energy, even as a twenty-year-old. While I was drinking in the culture the environment was chewing me to bits. I left school at the end of my third year and went looking for masterworks of art and a place to lick my wounds. I found both in the homelands of my old Swedeville neighbors. Europe was an ocean away, but it felt more like home than the city ever did.

I bought myself a $99 round-trip ticket and got on a plane headed for Milan, Italy. There I learned of a castle ruin being turned into an artists' colony by an all-volunteer labor force where I could get room and board in exchange for working six hours a day, six days a week. I headed straight for the heart of Tuscany.

The first time I glimpsed Cennina I was a long-haired foreigner pushing my bicycle up the steep, cinder-paved road that led to the fortified village on the hilltop. Its crumbled stone ramparts shimmered above the sun-baked countryside.

Oswaldo Rigi, an American-educated Italian count, ran the restoration project. It was his idea to turn the fourteenth-century ruin into a refuge for artists. He was tireless in promoting his dream, scouring the countryside for contributions of building materials and plying the social waters of nearby Siena for cash donations. For all his charm, Oswaldo was also a rogue. He played as hard as he worked, partying late into the summer nights. But he never failed to get out of bed and down to the little brick church at the end of the lane for morning mass, no matter how intense his hangover.

That summer of 1972 was a beehive of activity at Cennina. The morn-

ings began with a breakfast of toast and coffee. Then the pulley squeaked and the first bucket of water was hauled up from the bottom of the well at the center of the square. The mud crew made their preparations. Sand and cement were shoveled into a heap on the ground, and then the heap was spread out into a ring. Water was poured into the center where it was slowly absorbed by the circular dam. While the mud was making itself, the crew wheel-barrowed stone to where the masons readied staging. To qualify as a mason, you only needed to have worked there longer than the next guy. A cry would go out from the masons for mud. The wet ring was shoveled back together into another heap and then carried by pail up ladders and across staging planks to the ever-impatient trowel wielders.

Keeping bag cement in stock was crucial for Oswaldo. Without it, work came to a standstill. It was his one big expense but he was loath to spend any cash. When the supply got low he became frantic, extolling us not to waste any, and flew off down the road to find more. One day he came back with a long slab of cured ham. We'd been complaining about the meals (which mainly consisted of boiled, fried, or baked zucchini) for weeks, so the ham was a welcome sight. Oswaldo boasted that he'd convinced a butcher that we were all starving. The butcher took pity and donated the beautiful piece of meat. It hung in the larder for a while. Anxiously, we waited for it to be served. And then one day it was gone. Oswaldo was evasive when the crew demanded to know where it had disappeared to. Eventually it came out that he'd traded it for cement.

I was no stranger to construction; previous summers I'd pounded nails to make money for school. But I'd never been allowed to take my own initiative in a project, and I'd never worked with stone before. Oswaldo assigned me to dig out and wheel-barrow away tons of dirt from the bowels of one dark chamber. After I'd removed the dirt, Oswaldo explained that he wanted me to build up a foundation, with stone rubble, in preparation for the finished concrete floor. All the holes and hollows needed to be filled in so the thinnest possible surface of cement could be applied. I could see him calculating in his head the least amount of bagged cement needed to complete the job. He made a display of his magnanimity, assigning two recent arrivals the task of

supplying me with stone, but he ordered them to pile the rubble in the center of the doorway, in effect trapping me down in the hole. It was his idea of a joke, and had I been a little more mature I would have laughed along with him. Instead I just threw myself into the project with a vengeance.

While Oswaldo went away on one of his donation-hunting expeditions, I went to work trying to figure out how to make a flat floor foundation with stones of varied thickness. Trial and error led to a satisfactory working method. I fixed one end of a string in a corner, pulled it tight across the space, and leveled the flattest surface of each stone to just under the line. The finished surface fanned out as I pulled the string to different points around the edges of the room. By the second day, I started choosing the stone I wanted the hauling team to bring from the rubble field. I fit the edges of the stones as tightly as I could so no cement would get wasted in the cracks. As my work progressed, word spread around the site about the stone floor going in. People stopped by to admire it and praised my handiwork. That wasn't the reaction I got from Oswaldo, however. I had just finished when he returned and poked his mop of black hair through the doorway. He lamented the number of good building stones I'd used that could have been put to better use elsewhere. I offered to remove the best ones and replace them with rubble, but no, he said, leave it. I think he recognized that my careful work meant that less cement would be needed to finish the floor.

The foundation was covered with a thin coat of cement soon after. In confidence, other workers told me they thought it should have been left bare stone. I didn't mind that it disappeared. I'd found my pleasure in handling stone.

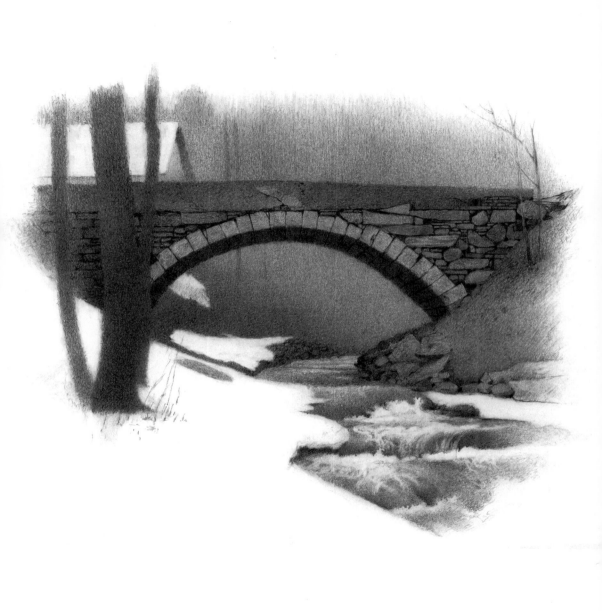

ARCHED FOOTBRIDGE

JAMES OTIS FOLLETT MILKED COWS, made maple syrup, and raised children but what he's remembered for are the many dry stone arch bridges he built in southern Vermont and New Hampshire. He grew up on a steep, rocky piece of ground, farmed by his widowed mother. It was the only life he knew until joining the Union Army to fight in the Civil War. During his enlistment he marched from Washington, D.C., to the battle of Gettysburg, and back. Notwithstanding his experiences in battle, the travel must have opened his eyes to many new and unusual things, including the stone arched viaduct of the Chesapeake and Ohio Canal—a bridge crossing a river, carrying water.

He was a deacon in the Townshend church and a commissioner of town roads in his time, but he must have been a dreamer too. Somewhere along the way a vision appeared for Follett wherein the weight of stone was held on high by the lightness of air.

Follett's life might not have been as remarkable as it was if he'd not encouraged his son to pursue higher education. The son, while studying civil engineering at Yale University, brought home a book on the subject of stone bridge and culvert construction. In it, Follett read that the shape of an arch can be described by hanging a slack chain from two points. Known as a catenary curve, it's the shape gravity naturally makes, and therefore, when traced and overturned, is the perfect shape to resist the forces of gravity. Soon after exposure to the principles detailed in the book, Follett, at age fifty-four, embarked on his second career. It was a case of the father following in the footsteps of his son.

With a team of oxen and an iron will, James Otis Follett built at least

one arch bridge a year for eighteen years. Building arch bridges became his relentless pursuit. He was driven to vault as many valleys as he could with dry stone. Obstacles and hardships were met and surmounted. In the course of constructing the double-arched bridge over Cold River, freshets twice washed out the timber falsework and brought down his partially completed arch. Twice he had to drag the salvageable materials from the water and begin the work anew.

Follett's bridges are masterpieces of artistry and engineering. Standing under the arc of one, with tons of granite overhead held aloft by nothing but weight and gravity, is an experience to take your breath away. It's even more impressive when you learn that the foundation of the structure is wood. Because Follett built his bridges for municipalities in the area, accounts of his contracts can be found in old copies of the annual town reports. Often the cost of shipping the stone from a quarry was as much as the stone itself. Most revealing are the line items that describe the preparation work before the bridges were built. Hemlock logs were flattened on one side and placed next to one another below the water level of the streambed. The wood mat is all the foundation there is under the bridge abutments. It allows the weight of individual base stones to spread out over a larger area, making any settling in the abutments uniform.

The stonework is kept from sinking down by the wood, and the wood is kept from floating up by the stone. If the logs were exposed to the air they would begin to rot, and their value as a footing would be lost. As long as they stay submerged in an oxygen-free environment they maintain their strength and durability. For years the logs have successfully done what they were intended to do, stay underground and underwater, underpinning the materials we usually consider the longer lasting of the two. Stone may endure longer than wood, but in some cases wood is what allows the stonework to last.

Follett's dry stone arch bridges are made as much from what's not visible, or what's simply not there, as they are from stones. Their arresting beauty lies in that defining space between the overarching stone above and the water's surface below.

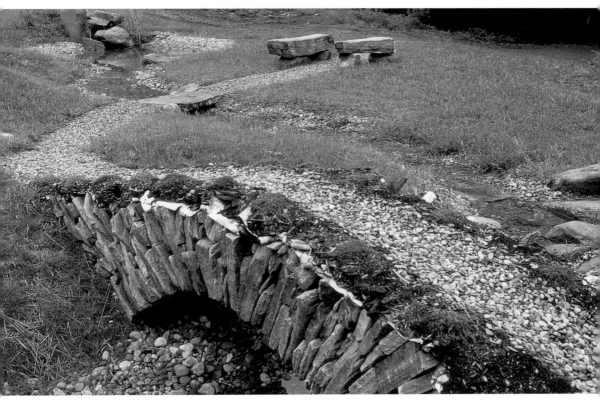

My own experience in arch bridge building is hardly worth mentioning in conjunction with the Herculean efforts of James Otis Follett. The bridge along the pathway at Thom and Gregg's place is the one example I have to my credit. I nailed together a temporary wood form and laid it between the stream banks. On it I brought a collection of flat stones up from both sides until it all met in the middle. The moment of truth came when I knocked out the wedges from under the form. It dropped down just enough so it could be pulled away, leaving the miracle of stonework floating on air.

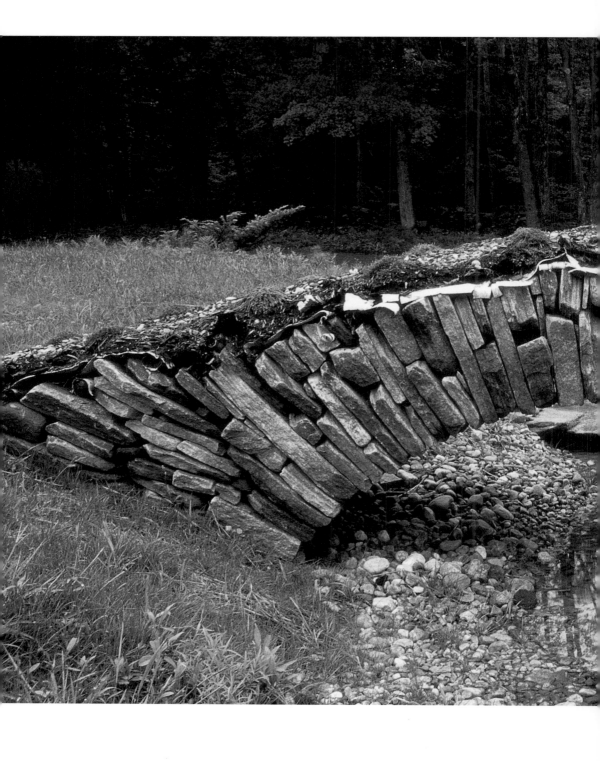

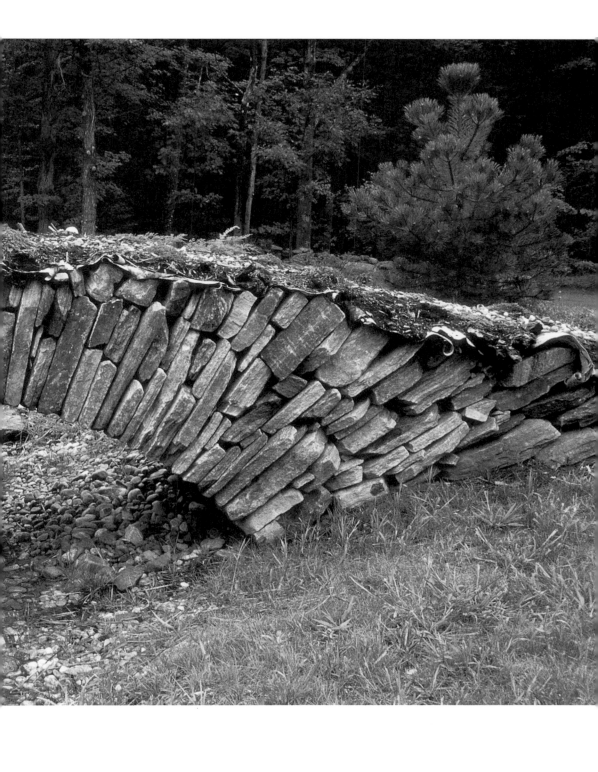

KNAPPING

KNAPPING STONE IS THE ACT OF BREAKING IT UP. THERE'S
the primitive, but also very sophisticated form of knapping that fashions
beautiful arrowheads from stone, and there's the heavy-hammer-swinging
method for bludgeoning stone to smithereens. The knapping that wallers
do falls somewhere between the two, requiring the finesse of the first and
the bull strength of the latter.

A knapper was not an uncommon sight along the byways of eighteenth-
century Scotland. Unfortunates who fell afoul of the law could do a kind
of community service to reduce or eliminate their jail terms. Assigned to a
stretch of county road bounded by farm fields, a felon was given a sledge-
hammer. Along the edge of the road were piled stones picked from the fields
by the farmers. The knapper went to work smashing the stones to gravel.
The gravel was spread to improve the roadbed. Even at that gross level of
knapping there's a hard way to do it and an easy way. The easy way is hard
enough.

The stone is struck dead center with the hammerhead aimed right
through to the bottom of the stone. When I was a kid, my father taught
me to box. He said if I was going to punch someone in the stomach, aim
for their backbone. The same principle goes for getting the most out of a
hammer swing. A hard surface underneath is better than soft ground, which
absorbs some of the impact of the blow. Even in the tightest knot of a stone
there is a grain. Finding it and going with it gets the stone apart with fewer
swings. Bringing a hammer down on a stone with as much force as possible
in every swing reduces the number of swings needed too. Muscle has a lot to
do with that but so does momentum. Starting a swing down low and getting

it up to near full speed before it reaches overhead leaves the second half of the swing to gravity. When the stone doesn't break from the first blow, and the hammer bounces back, that recoil is directed into the start of the next swing. The hardness of the stone helps lift the hammer.

For a waller (or "dyker," in Scotland) to knap a stone the aim is usually to shape it up, not destroy it. All stones are perfect the way the good earth created them, but to many a stone worker, they could be just a little better. Sometimes they go into a wall "as is," and that's as good as it gets. Other times the hammer is raised in protest of a perceived infraction. The weight of the hammer chosen depends on the heft of the stone, an eight-pound hammer for a two-man stone, and a four-pounder for a one-er. Offending parts are lopped off. Slashing blows, delivered on a diagonal to the top edge of the stone, tear off one flake at a time. They exploit the stone's weaknesses without completely overwhelming it. To be avoided is a "whack" straight to the side of the stone that might shock open a seam that could run straight across and split the stone in half. The stone wants to be kept whole, just given a haircut, trimmed on the sides and evened up in the back.

How a stone is banked helps determine how well the shaping will go. Raising the side of the stone onto a hard edge that parallels the intended line of the cut, and lies immediately under it, sets a limit on the distance the shock wave of the hammer blow will run. Without that grounded edge to cantilever the extraneous material over, the concussion of the blow might find its way to a weakness somewhere else in the stone and fracture it there instead. Banking on top of something hard, like the edge of another stone, gives a waller or dyker something to work toward, knapping from the

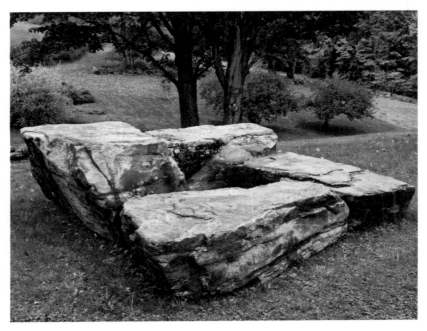

The shapes that nature makes are pure expressions of process. Once a part of the earth's homogenous crust, these four pieces sprang free from ledge outcrop and lay in a jumble on the forest floor. I gathered them up and made a simple arrangement that realigns them with their origins.

outside of the cantilever incrementally back to the completion of the desired shape.

The hammer comes down sharply and swiftly with the aim of lopping off one flake with each hit. In this way the unwanted material is nibbled off. Every strike breaks away some amount of stone. How much is determined by where the head lands and at what angle. The delivery of each blow is modulated to meet conditions. Stones with thicker profiles can be knapped along one side with a single series of blows, then flipped over and the other half of the thickness knocked off. Because we're talking about glancing blows here, ones that strike at an angle to the surface, more material is removed at the bottom of the hit than at the top. The leading edge of the hammerhead cracks a line on the stone, and the impact spreads out from there. The resulting spawls come off in clamshell-shaped chunks.

A hammer takes a lot of punishment. The head peens over on the striking edges. You can tell if a dyker is left- or right-handed by inspecting a worn hammerhead. The inside edge will be rounded over more than the outside. Opposite-handed walling partners can swap hammers when they start to dull up to get extra life out of them.

Every time a hammerhead is returned to the forge for reconditioning, it loses some mass. After a four-pound hammer has had its faces flattened back out a couple of times, it only weighs three pounds.

When a wood handle breaks off, the stub that is left in the head usually needs to be drilled to get it out. Hollowed out through the end grain the wood will break up and can be knocked out of the head hole. Another way to remove broken handle wood from a head is to throw it in the woodstove on a bed of hot coals. The wood will burn itself out of the steel.

A head that flies off its shaft while being swung is a menace to safety. Care should be taken to insure a secure connection between handle and head. The cycle of shrinking and swelling that takes place in a hammer handle when it is alternately exposed to sun and rain can loosen its clutch in the head. Norman Haddow is a "dry stone dyker" in central Scotland. His workday can be a veritable carousel of sun and rain. Norman follows his father's advice for treating a newly installed hammer handle. He soaks it in linseed oil once a day for the first week, one day a week for the first month, and one day a month for the remainder of its life.

Some wallers and dykers take great pride in their hammer work, considering it essential to the process of creating quality works in dry stone. Others would just as soon leave their hammers at home, relying on their ability to make the most of the stone as they find it. Whether or not a hammer is employed, the goal of every builder is to create a sturdy construction. The likelihood of that being achieved boils down to which stones are chosen, and when and how they are placed.

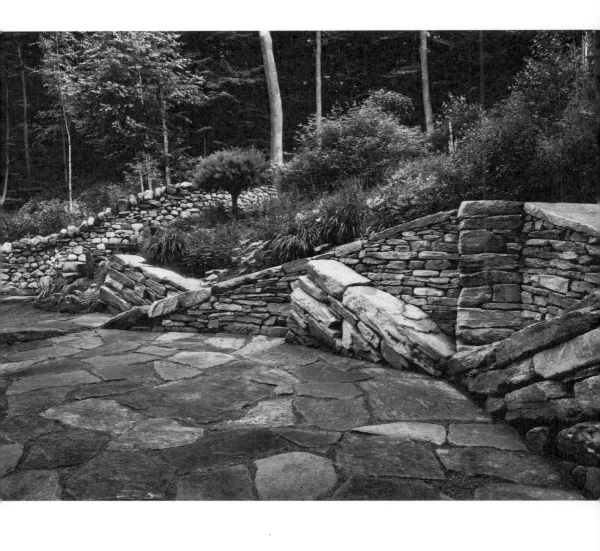

OFF BALANCE

CLIMBING OUT OF MY SLEEPING bag into the cool air and clear light of a Chaco Canyon morning, I began walking the trails of the Anasazi, looking for the remains of their nearly thousand-year-old dwelling places. The ruins were not easily spotted because they blended in so perfectly with their surroundings. The builders had tailored their pueblos from the fabric of the land. Stone was collected from the high country, carried down to the canyon floor, and laid up into pueblo walls. Clay-rich dirt was dug from the ground, mixed with water, and spread in thin layers between courses of stone. For hundreds of years, succeeding generations of Anasazi adapted spaces to meet their needs while adhering to, and expanding on, a general pattern and plan of construction established by the earliest inhabitants. There are ruins within ruins. Spaces were built, lived in, abandoned, and rebuilt.

Archaeologists look to the ruins as a cipher for reading the story of human habitation in New Mexico's distant past. At one time an earthquake shook the canyon, tipping and toppling pueblo walls. One old wall remains precariously out of kilter, the living record of a geologic calamity. Walls have gone to rack and ruin, but what they've lost in dignity, they've gained in personality.

As I wandered around the ruins, their striking forms and intriguing spaces caused me to ponder a notion. If it could be said that accident played a strong role in their creation, then accident must be a very good designer. I could do worse than to adopt accident as my mentor. And while I may not be able to design by accident, as happens in long-established, built environments, perhaps I could create accident by design; purposefully creating the

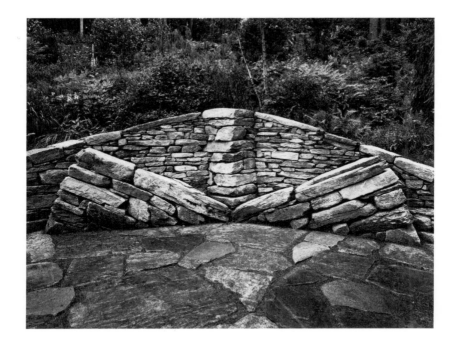

space and opportunity for accident to happen. In that way, I could make pieces of work that grew organically, within the parameter of a narrow time frame.

On return from my southwestern visit I started looking for the chance to build accident into my work. Bob Doyle and Greg Parks were looking for a retaining wall to buttress a steep bank on their property and left it to me to devise a plan. I plunged into the project by laying up two short pieces of wall with their stones on a bias to the horizontal. The place where the two met formed a right angle, so I started filling the space with square-cornered stones, and then knit them into an additional wall behind the two original sections. By not knowing what I'd find when I got there, along the way I created an accidental possibility. The experience of building the Thrust Wall, combined with what I saw in Chaco Canyon, explained to me why I find a tilted wall such a disquieting thing. It's a subconscious reminder that all around us, all the time, order is disrupted, overthrown, and realigned. In its

divergence from the strictly horizontal (that one dependable constant in our lives, Earth's horizon line), a tipped wall looks unstable. We build horizontal for the psychological sense of security it offers, more than for any structural advantage it may have.

I understand now why at the start of a project I strive to make a connection with the horizontal. The scene at most construction sites is chaos to begin with. Dirt is flung up and stone is scattered around. Until I get a course of foundation stones laid and tightly packed in place, I tend to feel adrift and flounder a bit in my discomfort. The more lines and planes I create that harmonize with the line of the horizon the more my confidence in the construction grows. With the Thrust Wall I forced myself to start off balance.

There are structural advantages in aligning a piece of work with the horizontal. The force of gravity presses most directly on a level plane. Stone that is bedded flat sleeps soundly. But at the same time, if all the stone is completely inert the wall will be a snoozer. It will perform its duty, but lifelessly.

Building with dry stone, there's a wide field of play to be found between the chaotic and the comatose. Stone that's been laid slantwise deflects and subtly redirects gravity's force. The wall's structure need not suffer when its stone strays from the realm of perfectly level and plumb. In fact, the matrixes of compressive force become more complexly woven into the wall when the stone shifts its weight from both feet, as it were, onto one foot, leaning into its shoulder.

When I started the Thrust Wall I didn't know what it was going to look like in the end. I let the materials and the space guide me along. Acts of the unknown, "accidents," took place. I witnessed them and absorbed them into the evolving plan.

I enjoy the stability of a placid existence but I know that occasional disruption and upheaval are necessary to stimulate fresh thought and circulate new ideas. It takes some willingness to let go in order to grow. I know I'm never going to learn any new dances by watching my own feet.

A "stile" is a cantilevered staircase built into a wall. The wall stones' weight fixes the step pieces in place. Most often a stile is included in a construction to facilitate crossing from one side of a wall to the other. It can also be used to simply step up a slope.

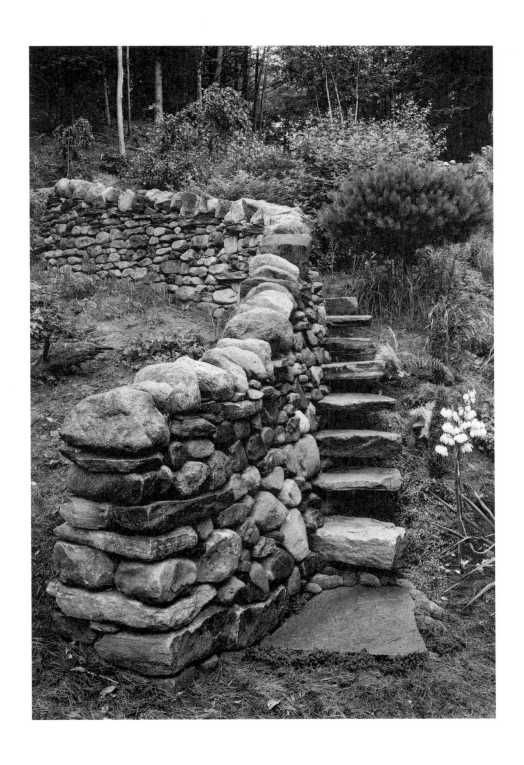

AUTOBIOGRAPHIES IN STONE

PERHAPS THERE IS NO BETTER EXAMPLE OF EXTEMPORANEOUS walling than the work done by the inhabitants of Ireland's Aran Islands. At the start of my pilgrimage to Inishmore, I sat in the back seat of a minivan as it bumped along the road from the ferry dock. Looking through the window, I was mesmerized by the seemingly endless lengths of loose stone wall that flew by. They hugged both shoulders of the asphalt road, keeping it barely one car wide. Linked to the roadside walls, and trailing away in every direction, were even more walls; an utterly confounding array of intersecting stone fences.

Had I sailed from Ireland's mainland with the early Christian monks who settled the island seventeen hundred years ago I would have seen only a bald dome of limestone escarpment rising out of the sea. The island remained sparsely populated until the eighteenth and nineteenth centuries, when rural Ireland's population swelled dramatically. Inishmore, and the other two Aran islands, caught the overflow. The people were determined to make arable land out of solid rock. In just a few generations they domesticated the islands with a painstaking application of sand and seaweed. They hauled it from the water's edge in willow baskets strapped on donkeys or slung on their own backs, then mixed and spread it over the barren ground. The intensity of their desire to build soil for potato cultivation is evident on every square foot of Inishmore. The potato mounds are gone now but the handmade soil is still there under the green sod that covers all of the ground, except, of course, where the walls stand.

As soon as I tossed my bag in my room at the boardinghouse I was off to explore the island on foot. I scrambled to a high point on Inishmore's nine-mile-long spine. It looked as though a coarse net, woven of stone, had been

flung over the island to anchor it in the Atlantic as a breakwater for Galway Bay, nine miles to the east on the Irish mainland. To the west I saw waves crashing against the base of high cliffs. The wind snatched patches of foam from the wave tips, cast them up and over the mile-wide island, and dropped them back into the sea on the other side.

While the network of walls only figuratively restrains the hulking island, they do literally contain its precious vegetation. The soil's hold is tenuous. Wind and rain threaten to erode it. Eighteenth-century farmers fractured the surface of the bedrock, broke away the smooth top layer, and exposed jagged fissures that helped to grip their new soil. The stone loosened was rendered into protective walls.

The walls don't look very substantial or sturdy. They're only one stone through in many sections and full of holes. To someone more familiar with styles of walling that are less "airy" and pay at least some attention to coursing, the method of construction used by Inishmore's wall builders might lead one to think that they weren't serious about what they were doing. Perhaps to them the walls were a mere trifle compared to the monumental job of gathering and hauling enough seaweed and sand to cover the island. Driven by the growling in their empty bellies, every member of every family worked the land. They weren't about to let a few million tons of stone slow the cultivation of the island. It's astounding that such a voluminous undertaking was approached so offhandedly. I got the feeling the walls were built by somnambulists, people unaware of the impression they were making.

Stones were placed with random abandon, but the wall shape and size was carefully considered. The guiding principle appears to have been to use the fewest number of stones to build the highest possible fence on the

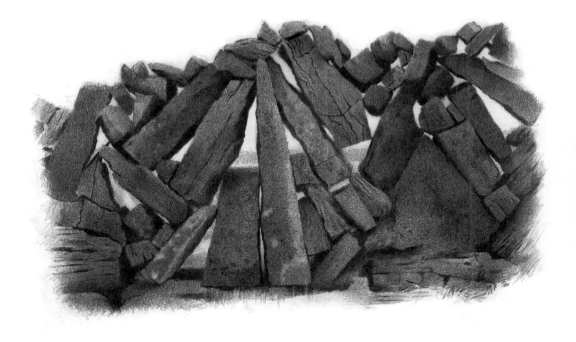

narrowest strip of land. They used the least amount of stone possible because they didn't want to break out any more stone than was absolutely necessary to scarify the surface. They maximized height to deflect the wind off their newly established soil. And they put down the smallest footprint to leave most of the acreage arable.

How did they have the confidence to erect walls using the bare minimum of materials? Dry stone walls traditionally rely on a superabundance of mass to sustain themselves through time. The ace up the sleeve of the Inishmore wallers was the base they set the walls on. The crust of the Earth is a most substantial foundation. Level surfaces of bedrock, squarely shelved where they change elevation, provide the ultimate base for wall stability.

The placement of stones within the form was influenced by geologic peculiarities and by the personalities of the individual builders. Aran limestone has a high friction quotient due to its abrasive quality; stones cling to one another and don't tend to slip apart. Therefore stones in a wall don't

need to be packed tightly in order to hold together. More holes allow greater height with less stone. And the wind is baffled, twisting and turning its way through the walls. Most of Inishmore's walls stand today as they were built despite the hurricane-force winds that regularly blast the island.

A dry stone wall with a width of twenty inches at its base, tapering up to ten inches wide at its top, is a slender object and looks delicately balanced on its base. The inward taper of the wall from base to top is strong enough to keep the wall from falling sideways from its own weight but not significant enough of an angle to reassure the eye that it won't tip over. The wall faces are coarsely textured. The cragginess makes the walls look as though they are crumbling apart. Stones lie at every conceivable angle. By most standards this would be classified as insubstantial construction. But in this place it functions beautifully and brilliantly. I'm tempted to say it is the work of genius—collective, eccentric genius.

At the time of construction, stone was cast into the walls with a fury matched only by the prevailing wind. With a torrent of wind blowing, a waller just had to start a stone toward its destination on the wall. The wind caught it up and flung it along. The waller directed the fusillade and tried not to be bowled over in the process.

The wind opened the wallers' minds to improvisation and swept the stone from their hands into unthinkably beautiful patterns. One wall stood out along the western horizon line. Backlight streamed through the voids. The stones, in silhouette, looked like a flock of blackbirds frozen in flight.

On my ramble, twilight descended and muted the colors of the day. Earth's imperceptible roll slipped Inishmore ever deeper into shadow. But not total darkness. The ocean's waxy surface shimmered from the phosphorescence churning beneath it. Starlight, reflected off the surface of the sea, was cast back up around the island. I don't think nighttime brought the Inishmore wallers' earnest endeavors to a halt. It's by feel the walls were made. The people worked through the night because they could. It was not a job they needed to see to do. Believing was seeing.

In the fluttering wind I heard the click and clatter of stone against stone and caught a whiff of ancient seabed rising from their points of contact. A phantom reached to the ground, hauling up one handful of stone after

another. His tattered clothes streamed away in black ribbons from his skeletal frame. He worked ceaselessly, unstoppable as the wind.

If I believed in my own path as truly as the builders of Inishmore's walls did theirs, perhaps I could have seen in the dark too. It would have helped get me back to the boardinghouse. As it was, I had a hard time finding my way. My foot got caught in a fault in the bedrock, my ankles tangled in the long grass.

If that ghostly waller should have happened to look up from his eternal toil I wonder what he would have made of my artless tumble across his ancient Irish island. Would he have thought me blind for not seeing the stiles, those assemblages of slightly protruding stones that provide a rough and ready staircase for getting from one field to the next? One stile after another seemed to magically appear when there was daylight. In the darkness I couldn't find them.

Eventually my eyes stopped straining to see what could not be seen. I let my legs lead me on, wading deeply into the earth's folds and stepping lightly on the crest of her swells. The night sky was a grand old clock face twinkling overhead. From invisible workings behind it came the imperceptible "tick-tock-ticking" of time immeasurable. Inishmore's welcome was plainly spoken.

I found the road again and followed it back. As the boardinghouse drew nearer, the window lights that had served so well as beacons seemed too bright. I hesitated to go inside. For a while longer I just stood outside in the dooryard and listened to the wind.

For all their great length and breadth, it was in the details of Inishmore's walls that I most delighted. Through the handiwork, personalities revealed themselves. Self-deprecation appeared alongside braggadocio. Without being aware of it, the wall makers of Inishmore wrote their autobiographies in stone.

LINE

TO FAMILIARIZE MYSELF WITH THE GEOMETRY OF A BUILDING site and to help me see what might ultimately be, I get out the sticks and line. The sticks are pounded into the ground to act as visual reference guides, anchor points for line, or describe wall batter. Line can be pulled straight between points in space or arranged loosely in curves on the ground. When not in use, line is stored by winding it around a board with an H-shaped profile. It doesn't get all tangled up if it's returned directly to the board after use. Mason line, the braided not twisted kind, doesn't stretch out when pulled tight and doesn't fray or unravel when cut.

Line is reused on job after job, cut and knotted back together until over time it bristles with many pairs of short hairs and begins to resemble a strand of barbed wire. "Cutting" doesn't accurately describe how line is severed into useful lengths. It is laid on a stone and "mashed" in two with a hammer blow. Not that a knife wouldn't do the job; it's just that a hammer is more often right there, within reach. The tool at hand is the one that gets used.

A cow hitch is a simple way to fasten the line to sticks, or to the batter frames that are used for the final construction. The name comes from the hitch's most common use: tethering a cow. The hitch slides around the post but doesn't come loose, as the cow grazes. It's just two half hitches looped in opposite directions. The advantage a cow hitch has over more complicated knots is that it can be applied one-handed and can easily be snugged up if the line sags. Keeping taut lines throughout the building process helps maintain tolerances and one's original vision.

Lines suggest volume and delineate form. A ghostly image of the future wall appears when lines go up. They imply substance. So much so that as soon as they are strung the wall becomes real in my mind. With lines in place it's just a matter of time, and filling in the blanks.

After the stones are in, a well-constructed wall has an easy look about it, as though it poured itself into place. All signs of the tussle have vanished.

For a few weeks, over the course of four different summers, I built this Secret Garden for Michaela Harlow to contain soil and shield her plantings from the incessant wind that whistles across the top of her hill, located at the southerly terminus of Vermont's Green Mountain range. I built walls, stepways, and a fire circle, finishing the stone work on one side of the house each year, just barely keeping ahead of her ambitious planting scheme.

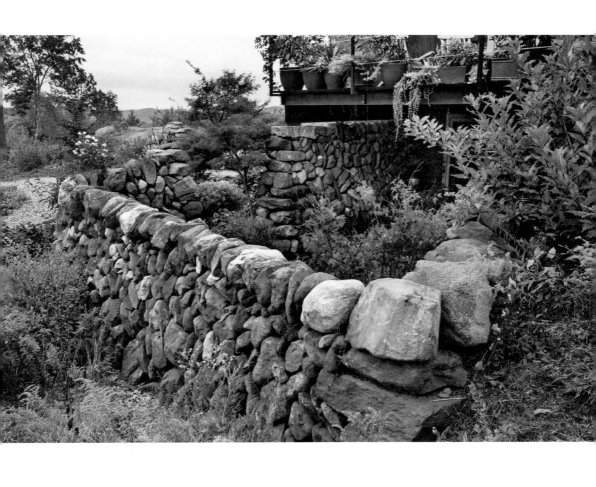

L E V E L

IT'S KIND OF CURIOUS THAT A TINY BUBBLE SHOULD BE A ruling force in the weighty matters of stone construction, but on every job site there lies a level, and with regularity it is picked up, oriented to the work, and read. The information deciphered through the level's vial of liquid spirit is accepted as doctrine, the final word of the day. For the hard-bitten worker of stone, it is perhaps the only time truth will be found in a bottle. Maybe it's because it is the bubble telling the story, and not the alcohol, that a level ranks right up there as one of the most accurate and dependable tools on the job.

The moral of the bubble's story is this:"Without that which is missing, what is there cannot be measured." The spirit in the vial communicates through the medium of proportion. A vial full of spirit gives no reading, a vial empty of spirit, the same. There must be enough spirit to float and trap the bubble without inhibiting its freedom of movement. Or more precisely, the spirit must be allowed to move around the bubble so that the bubble may remain at the highest point in the vial no matter how the level is turned or tipped. The bubble is compelled to reach the upmost limit of its confinement.

And the level works in all weathers. The tightly sealed glass protects the alcohol from evaporation, and the spirited liquid protects the glass from bursting when exposed to below-freezing conditions.

Measuring devices have become more sophisticated since the invention of the spirit level to where we can now establish the physical relationship among any number of points via satellite. Finding "level and plumb" is something modern technology does very well and keeps getting better at. But the underlying quest stays the same. It's older than the hills we calibrate.

Establishing fixed points is a preoccupation of humankind because, from them, perceived changes can be measured. We want to know things in order to have something to compare to all that we don't know. All of our makings and doings illuminate our place in time and cast a feeble light forward. What we leave behind us as we go are like bread crumbs dropped along the path, except we can't turn and follow them back.

Perhaps the unknown is our one true fixation and all the things we actually do in a day are only contrived to deny that fact from ourselves. Ahead, in continuing manifestation, comes the peril of the unknown, against which we giddily fortify ourselves with furious activity and amazing creativity. Behind, the known becomes obscure the further it retreats until finally disappearing into the vastness of the long ago.

I admire the bubble in the spirit level for its perseverance in always reaching the highest ground. I appreciate its evenhanded criticism of my work and respect the reliability of its forecasts and prognoses. Pluck, forthrightness, and humility are rare in combination.

A garden is defined by its plantings, but it is ultimately measured by the quality of its atmosphere. By atmosphere, I don't just mean the mood or aura of the garden. I'm talking about the actual air there, the gaseous medium enveloping the garden. Dry land is Earth's second seabed. An ocean of air, miles deep, slides, swirls, and curls around the skin of the planet. Garden atmosphere is a bubble of refinement in the sea of air that washes over us. It is a permeable capsule clarified by the absorption and reflection of garden colors, textures, and aromas. The measure of a garden is in the air that clings to it.

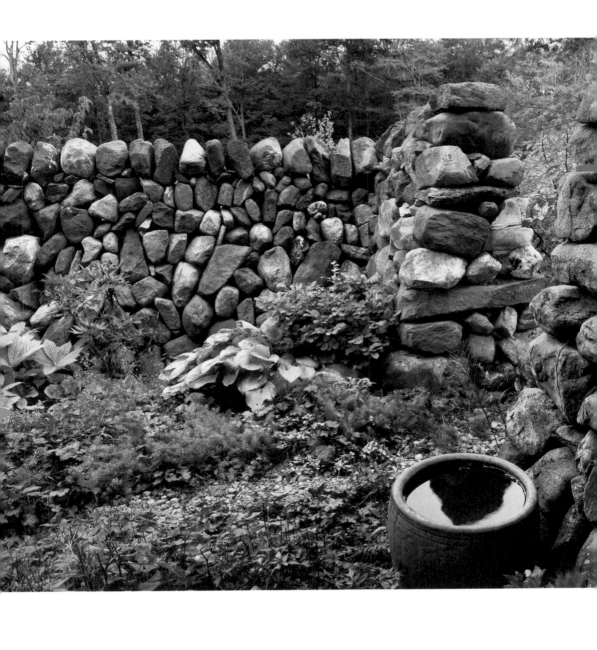

THE GALLARUS ORATORY

EXPRESSIONS OF PLUMB AND LEVELNESS COULD BE SAID TO be the essence of all the world's great religious traditions if the architecture that enshrines them is taken as the guide. For the builders of Ireland's Gallarus Oratory it may have been their own internal search for balance that inspired them. At one time the oratory was the centerpiece of an early Christian monastic settlement. Now, the unimposing edifice rests on its haunches alone in the countryside of County Kerry. To its back rise the sheep-shorn highlands of the Dingle Peninsula. To its front, the vista sweeps westerly down to the shores of the sea. The heavily trod yard of the chapel is bounded on four sides by field walls. One autumn day I added my footprints to the oratory's many layers of history.

The shape of the Gallarus Oratory is like two cupped hands touching fingertips. The exterior sidewalls bow in as they rise, become the curved slopes of the roof, and meet at the stone-capped ridge. Every course of gritstone is angled slightly to direct rainwater away from the structure's interior. The worship space remains dry in spite of the oratory's exposure to pounding North Atlantic gales. For twelve hundred years, pilgrims have stepped from under the bright sky, across the worn threshold, into a space delineated by only a trace of incident light. The corbelled ceiling above the packed earth floor is barely discernible through the gloom. Whispers of ancient prayer hang in the motionless air.

The structure's perfect balance is achieved through symmetry. The doorway and window are centered on the end walls. The builders took great care to generate identical complex curves for the building's profile. The details

of the structure are simple and masterly. Cut and dressed blocks outline the corners and openings. The faces of the roof stones are trimmed at angles to match the different radii along the curves.

The old chapel serves its humble purpose with simple monastic dignity and lasting structural integrity. There may not be a more perfect synthesis of materials, technique, form, function, and spirit than the Gallarus Oratory.

TWO BOATS

IN AN ATTEMPT TO EMULATE, IN A small way, the feel of the oratory, I undertook the building of a stone dinghy. I wanted the upturned boat to have compound symmetrical curves. I wanted the stone coursing to mimic the lines of a wood dinghy's lapstrake construction. I wanted the unfloatable boat to have an air of mystery about it.

Before starting to lay the stone that would become the boat, I bent steel rods and welded them together into the bare outline of a twelve-foot-long dinghy. I set the wire template on the ground and started laying stone, gathered from the property, up inside it at the same angle the dinghy was tipped. One rail, or gunwale, of the landlocked watercraft was hiked up above the ground. The stone was cantilevered to create the shadowy illusion of an interior space. With the stone laid, the steel template was removed. The first dry stone dinghy was beached in Phyllis Odessey's Marlboro garden. From there I moved the template to the front yard of Will O'Donnel's home in Stratton and built a twin dinghy, but with a different type of stone.

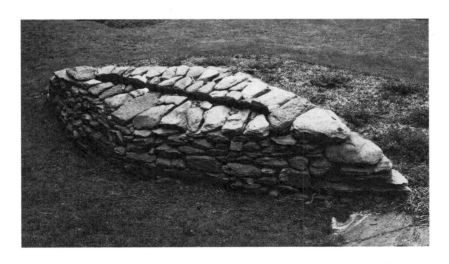

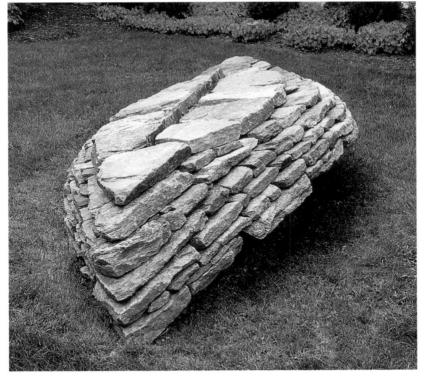

Fire watching and star gazing are rural entertainment's double feature. Pairs of standing stones make back-to-back recliners that face the fire glow or cool night sky.

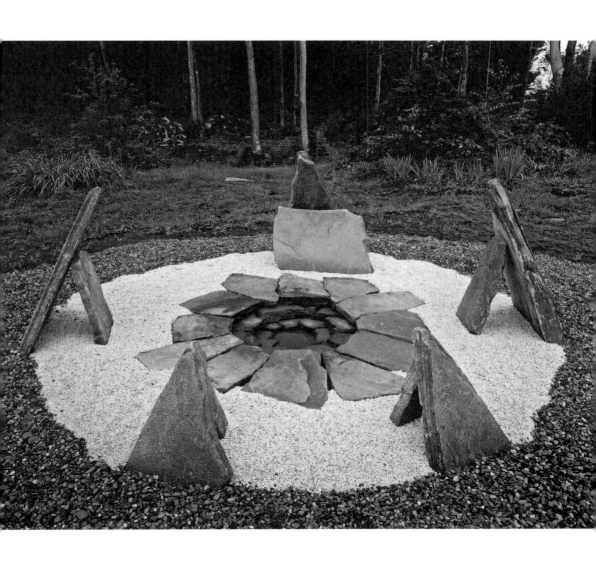

ONE PILLAR BUILT TWICE

 I'M GUESSING THAT I'M NOT THE ONLY holder of a Dry Stone Walling Association Craftsman certificate who has felt at times undeserving of the designation. On occasion, in the twelve years I've held an intermediate, or higher, certificate, my standard of work has slipped below my certification level. Without making excuses for why it's happened I admit that it has. I've worked wall up on top of wobbly foundation stones, and done some pinning from the face instead of from the back of the construction. There are many ways working wallers can fail to insure that their level of certification reflects the standard of their work.

Thus it was to my great chagrin that I discovered the fault in my master craftsman examination timed test piece. After standing firm for three years, the round pillar began to fail. Gaps widened between face stones, the profile bulged, and copes spread apart. The construction had an inbred weakness that began to show and grow.

The DSWA Craftsman Certification Scheme is a touchstone for wallers all around the world. Its clear outline for excellence in the craft of walling is backed up by the diligent staff at the DSWA office in Cumbria, England, by devoted committee members, and by the professional team of test examiners. Anyone striving for certification wants to know that their work and that of others' is judged equally against a set standard. And those who have achieved certification want to know that the testing standards remain high.

I should have handed in my master craftsman certificate the day I saw the flaw in my test piece. Instead, I pulled the piece down and rebuilt it. The

mistake I made in the original pillar was the stone I picked for building it. The stone was very friable. Pieces long enough to span the diameter of the circle were nonexistent. Through-bands had to be fabricated by overlapping two stones at the center of the circle. But that wasn't enough to tie opposite sides of the column together. After a while the half-throughs began to slide apart. The pillar began to expand under its own weight.

When no through stones exist in a stone supply it is acceptable, under test rules, to substitute overlapping pairs. Technically, the examiners of my stint judged correctly in awarding it passing marks. Unfortunately, for the pillar and my ego, time gave it a failed grade.

By rebuilding the pillar using additional stones of a type long enough to span the circle I moved one step toward redemption. My active support of the certification scheme, and walling in general, is another step. Through instructional workshops I try to help beginning wallers avoid mistakes similar to the ones I've made over the years. Also, by working as an examiner for the DSWA Craftsman Scheme I offer experienced wallers opportunities to compare their work with a well-regarded standard.

The association reserves the right to ask any individual to attend for reexamination. Since my debacle with the pillar I keep an application for retesting on my desk, filled out and ready to send in.

Not all of my work has been an unqualified success on the first attempt. Still, a bad day of walling will always be better than a good day of housecleaning.

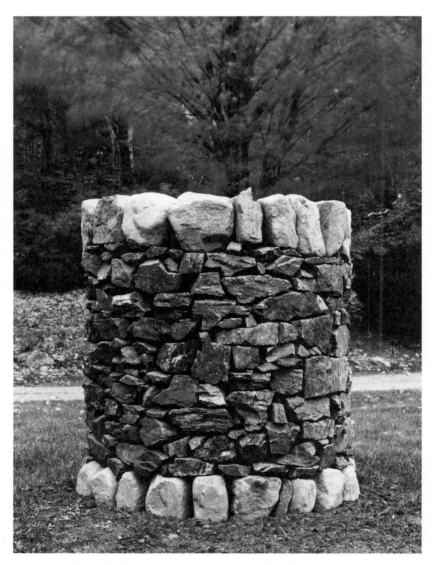

Dismantling and rebuilding one's own work can be disheartening but also an excellent learning experience. It's a study in anthropology and archeology on a personal scale. As the piece is dismantled, emotions involved with the original work's creation are revisited, and construction is analyzed for both good and bad qualities.

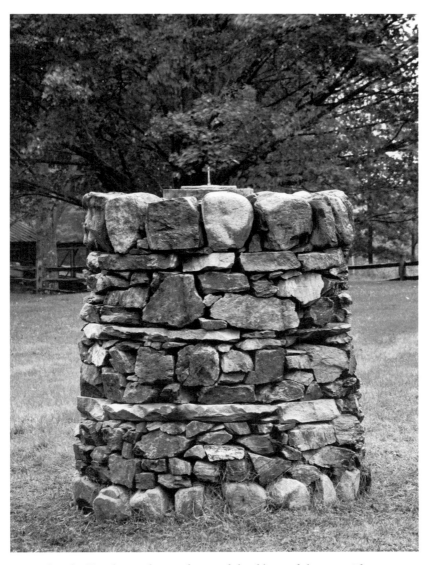

As the rebuilding begins the significance of the old piece fades away. The act of creation makes each moment new.

EAGLE TRAPPER'S HIDE

HIKING ON ONE OF NORWAY'S LOFOTEN ISLANDS I discovered a most curious artifact in dry stone: an eagle trapper's hide. Historical accounts ascribe the 1860 creation of the unique hunter's blind to a man called Hallstein, an apt name, considering that the word *hallstein* can be translated to mean "stone cave." The hide is an enclosure just large enough for a person to crawl into. The trap is a six-foot-round stone bowl situated on the slope above the hide. An eagle, lured by a piece of carrion in the bowl, was grabbed by its leg through a small hole in the hide's ceiling and yanked below to have its neck swiftly wrung.

Sheep still graze on the desolate slopes of Moskenes Island's far reaches, but the farmstead at Mulstøa, Hallstein's former home, is abandoned. Mulstøa is a small sheltered bay with a crescent of sandy beach, the only spot like it for miles along Moskenes Island's rugged east coast. At the isolated croft, Hallstein kept poultry, grew potatoes, and raised sheep. There is no road to Mulstøa. Travel to and from the croft was by boat; it was an hour's row in calm seas to the closest village.

Mulstøa's most recent inhabitants shipped out in 1949. All that's left in

evidence of the lives lived on that windy coast are a few building foundations and a stone-lined well. A mile from the old settlement, nearly invisible in the rubble of a rock slide, is the eagle trapper's hide.

Examining the simple ingenuity of the hide I wondered if Hallstein had been successful in defending his flock against airborne predators. As though in answer to my question an eagle took flight from the rock face above and soared majestically among the peaks. Clearly he hadn't managed to trap all of the eagles. With the broad sweep of the sea below, sheep scattered among the rocks, and the dark mountains above, it wasn't hard to imagine the events surrounding Hallstein's building of the hide. The making of a thing is the telling of a story as it happens. The maker hears it firsthand. After it's finished, the object made retells the story, but in its own way.

Hallstein took the materials at hand and fashioned them to his needs. His trap was ingenious in its simplicity. The inspiration for its creation came out of more than just that one moment of anger and frustration with a winged predator. It grew out of years of interacting with his environment. His work on the land fed his mind as well as his belly.

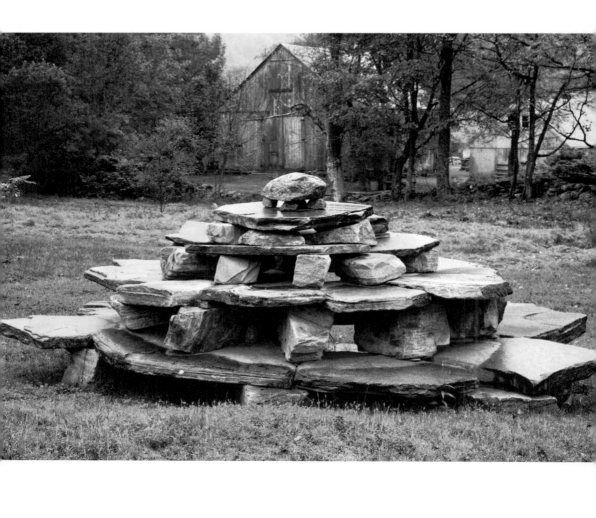

STAR SHRINE

 HOWEVER BROADLY I WISH TO SPREAD the implications of touching Earth's stone it always comes back to the doing. Putting stone on stone into a wall is like putting one word next to another in a story. The possibilities are endless, so choices must be made. It takes just two words to begin. Two words knocked together can spark a chain reaction. Two words can create enough energy to rumble the imagination. With two words comes a way. They pull and tug at each other, stretching each other's meanings, slinging each other in tandem far across the universe of ideas.

When I first heard the term Star Shrine, and understood that people in the past sometimes made places for the worship of celestial objects that had fallen to Earth, my breath was taken away. The great sweep of possibilities held in that simple notion set my mind racing. And when I heard that many "Hoshi Jinja" in Japan are still revered despite the fact that the meteorites they once sheltered have long since been removed or stolen, I knew I had to build one.

A place may gain stature by association with an object of importance. While a treasure may disappear, the place it was kept remains and continues to be honored. In that way, the memory of something special is maintained. In the case of an empty Star Shrine, memory replaces the absent meteorite, memory becomes enshrined.

I was shocked into wonderment the day I discovered my meteorite, or at least what I believed was a meteorite. Pulling stones out of an old discard heap below the edge of a farm field I grabbed a stone that felt way too heavy for its size. The poundage put me off balance and left me a little light-headed. When you handle all shapes and sizes of stone, day after day, year after year,

you develop a certain expectation of what they're going to feel like when picked up. With all the lifting I do I depend on that acquired knowledge to keep me safe and healthy. This stone was a dark, roundish lump, the size of a loaf of bread, its surface smoothed from long wear grinding along in some past glacial advancement. It was just a stone, but something more than just a stone too.

So pleased was I with the find that I immediately shared its discovery with the property owner. He took it and gave it to his son, who in turn gave it to a geologist cousin for inspection. The memory of having that stone in my hands stayed with me for years.

I did inquire of its whereabouts sometime along, but no one seemed to know what had become of it. Maybe it was merely a stone after all, one with unusually high iron content. I prefer to believe it fell to Earth in a ball of fire, was locked deep in a mountain of ice for thousands of years, and was eventually spit out in a slurry of dust and debris onto the naked earth. We met briefly in passing one day and then went on our separate ways.

The Star Shrine is dedicated to the memory of lost things. It's a reminder to remember a time of wonder.

WALLING WEATHER

"WE ARE HAVING SPLENDID WEATHER AND I AM BUILDING *a stone wall.*" So begins a letter from the author E. B. White to a friend. "*I understand that all literary people, at one time or another, build a stone wall. It's because it's easier than writing.*"

It must have been a strong temptation for E. B. White to leave his writing desk, get outside, and work the land of his Maine farmstead. When the weather is fine there's no more pleasing way to spend your day than building a stone wall. For hours you can clamor around in a mess of earth and rock, without interruption, because to the world passing by, the making of a stone wall appears to be dull, strenuous, dirty stoop-labor and seldom solicits a second glance.

In the landscape, soiled clothing and a battered hat disguise the inner workings of the active mind of one who thrives in an atmosphere of solitude. Like Brer Rabbit, born and bred in that same briar patch he begs Brer Fox not to fling him into, the waller wallows blissfully in a self-imposed exile of dust and grime. Writers too crave long uninterrupted stretches of time to sink themselves into the depths of concentration. In a room, barricaded against intrusion, a writer chops away at the keyboard, carving out an image in words.

At either work site your sense of place changes dramatically when an outside observer enters the scene. Observation punches a hole in the psychic container you create around yourself, whether doing walling or writing. Your best work is done in that rarefied air of compressed mental oxygen. The work stops doing itself when self-consciousness creeps in, when you are no longer the invisible partner in the process. While a morn-

ing of walling can literally fly by when you are on your own, if someone steps up behind and watches, those minutes become interminable. Alone you can set your mind loose to play in the wide open fields, but when there's company afoot you need to call it back over the threshold of consciousness and extend the courtesy of attention to a guest, in spite of any remonstrations on their part to continue as though they weren't there.

With wall building, your progress makes its own pace. Successes and setbacks are duly noted in passing and accumulate into what becomes the character of the wall. Writing can be a more illusive catch. The process is slipperier to grasp, because it's nonlinear. Words and phrases can be moved back and forth among the pages. The success of either enterprise depends largely upon your ability to resist temptations. In writing you cannot become too attached to your efforts, no matter how hard-won. You must constantly dig into the accumulation and discard all that confuses understanding, obscures meaning, or has lost relevance. In walling you force yourself to lay each stone with its length into the wall, rather than along the face, because structural integrity always trumps appearance. And you deny the temptation to leave a vertical running joint in place, believing it will disappear from view after additional wall is built over it, because it won't.

You may be fatigued by the time the sun dips below the treeline, but the bone weariness is remindful of a day well spent with stone and is the harbinger of a good night's sleep. The work of writing is light lifting compared to stone wall building. But that makes it only more difficult to put behind you when it's time to stop. There's no end to the mind's facility to formulate and manipulate ideas. Very few calories are burned applying those ideas to paper. Stones don't follow you around the house, litter the supper table, or get under the bed covers with you at night the way words can. Hefting stone is a self-limiting affair. The body demands rest, and the wall builder must eventually oblige. While a writer may struggle to shut down "the workings" at the end of the day, a laborer needs no reminder to drop the shovel at "beer-thirty."

Wallers and writers are creatures of habit, they thrive on routine.

Spending hours on end in a solitary pursuit is what writers do every day, so it should be no surprise that a solo occupation like stone wall building would appeal to them. I wonder, though, if E. B. White would have been so enthusiastic about building his stone wall if the weather had been something less than splendid. The work of walling becomes more difficult on those summer days when it's so hot you can barely see due to the salt in your eyes and the sweat falling off your face, streaking the lenses of your glasses. A cold wind whistling up your pant legs on a morning in late autumn makes you want to retreat to the warmth of home and hearth. Despite the leaden skies, I know I should be out there in my rain suit and rubber boots, knapping stone, because, as the saying goes, "Wallers Work in All Weathers." But on such days, the temptation to go back inside and do some writing gets pretty strong. "We are having wretched weather and I am writing about a stone wall. I understand that all dry stone walling people, at one time or another, write about a stone wall. It's because it's easier than walling." You can quote me on that.

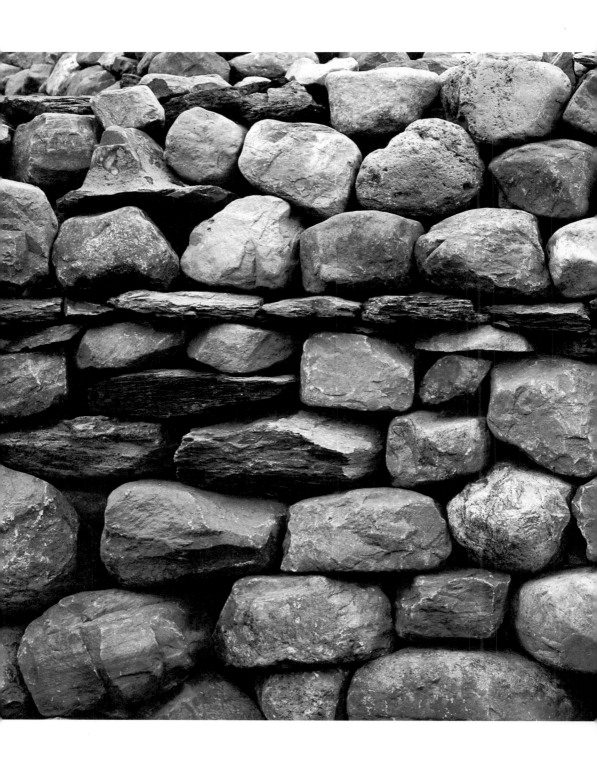

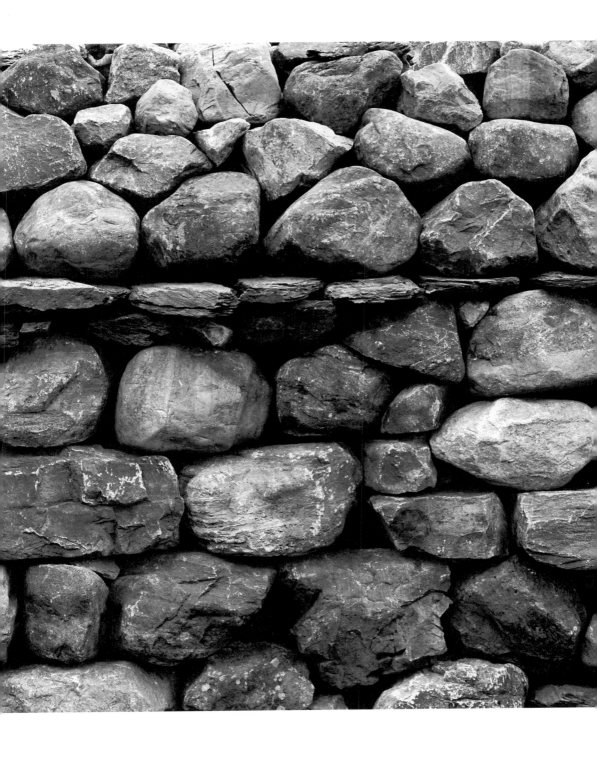

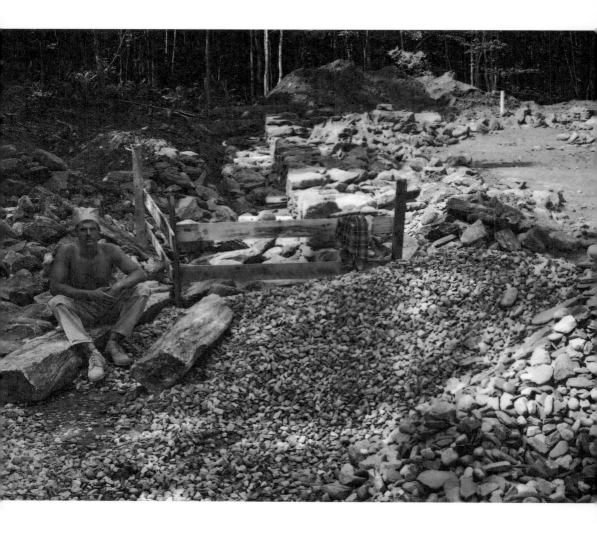

WRESTLER

IT'S ONLY APPROPRIATE I END THIS WANDER BY WENDING my way back to an early year in my walling career. By 1982 I had been building with stone professionally for six years. I felt pretty confident about what I was doing. I'd already repaired great long lengths of old field fence and built new retaining walls to head-topping heights. It seemed to me I'd done it all. There couldn't be much more to dry stone walling past what I already knew. From my narrow perspective I was a veteran of the trade.

I look at myself in the photograph Peter Mauss made that summer and see a young card player who's not quite ready to show his hand. The job I'd taken on was to build a barn foundation, my second one in three years. The previous construction was built on ledge, so the footing was assured. This one was coming up out of wet ground. I packed a four-foot-square trench by hand with the least desirable members of the stone stockpile and with the remainder built a two-foot-high wall to support the barn's timber sills. The portion of construction that disappeared belowground took twice as long to build as the visible, above-ground bit. I sit as the photographer instructed, beside the batter frame, among the stockpiles, a brown paper bag keeping the sun off my head, and try not to move. I was half impatient to get back to the job and half gratified to have my work chosen as a subject of documentation.

Doing that same job today I'd use a front-end loader and fill the footing trench with six-inch crushed stone. The foundation would be finished in four hours. In 1982 I slaved away for two weeks down in that 250-foot-long perimeter trench. Either I didn't know there was a more reasonable alternative for preparing a wall base or I simply refused to consider other options. I don't remember which it was, but even money says it was the latter. My

self-esteem sprang directly from my intractable disposition. It was nothing I'd ever admit to myself at the time and it's embarrassing to own up to now, but I held fast to my points of view, whatever they were, and didn't let go. If my belief was unshakable then it must be right, and that made me good. I saw things pretty much in black and white in those days. I stayed clear of the gray areas, where boundaries were unclear, because uncertainty opened the door to compromise, and in my book, compromise was a character weakness. In both my professional and personal life it was my way or the highway. If I only knew now as much as I thought I knew then.

It took awhile, a solid fifteen years, I'd say, to fully accept the fact that I wasn't always right and I didn't always have the answer. Yes, I am a charter member of the Slow Learners' Club. But now I understand that it's in the gray areas that life is most fecund and that getting the most life has to offer means moving off the frosty high ground and sloshing through those warm muddy waters. Loss, grief, hope, and joy are all there to be encountered in their turn. Dry stone wallers are not excused from bouts of existential mud wrestling just because they choose to tussle with the physical world every day. Those of us who are willing to embrace all that life has to offer, at whatever emotional, spiritual, or physical level we find ourselves, have the best chance of finding ever-new joy along the way.

ACKNOWLEDGMENTS

FOR THEIR INSPIRATION, GUIDANCE, AND SUPPORT DURING the making of this book, we have many to thank: Peter Aaron, Will Ackerman, Teddy and Peter Berg, Ann Bramson, Charlie Braun, Candace and Frank Burkle, Lars, Andy, and Kyle Cartwright, Thom Dahlin and Gregg VanIderstine, Chris and Becky Dayton, Richard Epstein, Chris Gallagher, Karen Gersch, Chris Gray, Michaela Harlow, Stephanie Huntwork, Kaori Hamura and Bill Long, Jeff and Ted Hetzel, Devon Jersild and Jay Parini, Veronica Kadlubkiewicz, Barbara and Ernie Kafka, Mallory Lake and Bob Engel, Sigi Nacson, Phyllis Odessey, Will O'Donnel, Greg Parks and Bob Doyle, Helen and Blake Prescott, Jill and Kip Record, Ruthie Redpen, Susan and Rick Richter, Camilla Rockwell, Angela Snow, Erica Stoller, Harvey Traison, Joanie and Nicholas Thorndike, Anna Tunick, Virginia and Peter Vogel, Terry and Steve Walton, Carol and Jerry Ward, Rebecca Welz, and Peter Workman.

.